IMAGES
of America

SILENT-ERA FILMMAKING IN
SANTA BARBARA

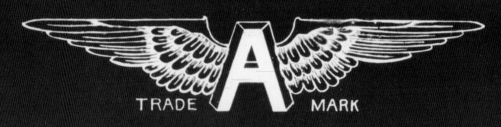

TRADE **A** MARK

AMERICAN · FILM · COMPANY

INCORPORATED

· SANTA · BARBARA · STUDIOS ·

A frame enlargement of the end logo of a "Flying A" film probably dates from 1916 or 1917, after the company shortened its original corporate name from the American Film Manufacturing Company in 1915. The Santa Barbara location of the studio was a selling point in the Flying A's promotional efforts. The studio turned out nearly 1,000 films in Santa Barbara, California, between 1913 and 1921.

ON THE COVER: Actor-director Frank Borzage (with hand on tripod) and cinematographer L. Guy Wilky shoot a scene for the 1916 film *Land o' Lizards* at the American Film Company studio in Santa Barbara. The large saloon set was built outdoors with the ceiling open to the sky. Overhead muslin diffusers softened the sunlight used to illuminate the scene.

IMAGES
of America

SILENT-ERA FILMMAKING IN
SANTA BARBARA

Robert S. Birchard

ARCADIA
PUBLISHING

Published by Arcadia Publishing
Charleston SC, Chicago IL, Portsmouth NH, San Francisco CA

Printed in the United States of America

Library of Congress Catalog Card Number: 2006938521

For all general information contact Arcadia Publishing at:
Telephone 843-853-2070
Fax 843-853-0044
E-mail sales@arcadiapublishing.com
For customer service and orders:
Toll-Free 1-888-313-2665

Visit us on the Internet at www.arcadiapublishing.com

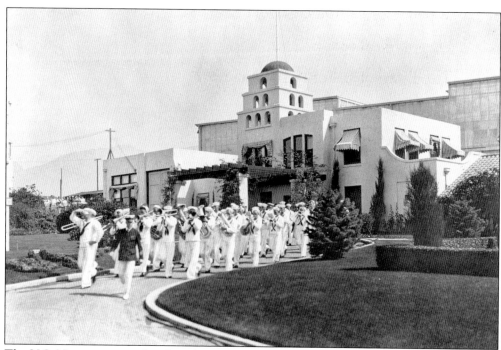

The U.S. Navy recruiting band paid a visit to the Flying A studio on June 5, 1919. After the American Film Company ceased active production in the early 1920s, the lot was rented for a time to William Randolph Hearst's Cosmopolitan Productions and served as a National Guard armory and community dance hall before it was torn down in the late 1940s.

CONTENTS

ACKNOWLEDGMENTS

All of the photographs in this book are from the author's collection. Many of these pictures were given to the author by people who worked at the American Film Company or Flying A studio, including Marjorie Overbaugh, Jodie Eason Frame, Gerald Carpenter, Grace Meston Higgins, L. Guy Wilky, Allan Dwan, Henry King, Edward Sloman, Helen Armstrong, and Leontine Birabent Phelan. The author also wishes to acknowledge Michael Redmon of the Santa Barbara Historical Museum, who helped identify some of the buildings in the photographs, and to give special thanks to fellow Arcadia author Jennifer Dowling for helping get this project started. Also thanks go to Marc Wanamaker/Bison Archives.

INTRODUCTION

Today everyone knows the 1937 song "Hooray for Hollywood!" and is aware that Hollywood, California, (along with its immediate geographic neighbors like Burbank, Universal City, and Culver City) is the movie capitol of the world. But if Johnny Mercer and Richard A. Whiting had written their song in 1915, they might have just as easily declared: "Hooray for Fort Lee . . . or Philadelphia . . . or Jacksonville . . . or Chicago" Production companies flourished in all of these places and other cities across the United States in the years before World War I.

One of the most successful early motion-picture studios was the American Film Manufacturing Company, established in Chicago in 1910 as an independent rival to the licensed firms that formed the Motion Picture Patents Company. The Flying A soon found it advisable to send its filmmaking troupe away from the windy city to avoid attacks and reprisals from hired thugs who were determined to put an end to the upstart firm's activities.

They settled for a time in La Mesa, California, near San Diego, but soon used up all the local scenery and decided to establish a studio in a location that would offer limitless scenic possibilities, year-round sunshine, and rail access to the company headquarters in Chicago. After scouting locations up and down the coast, they settled on Santa Barbara.

The town was a popular resort for well-to-do easterners—which presented a problem for many local merchants. Storekeepers often complained their rich patrons would come in for the winter, run up large tabs, and return east without settling their bills. The new film studio was a mixed blessing. Cowboys charged over the nearby hills holding up stagecoaches and shooting off .45 blanks, cars raced through the streets careening around corners at breakneck speed, and the film folk—actors and directors—were not always in tune with what polite society expected. Fifteen-year-old star Mary Miles Minter was sneaking into hotels to meet with her 42-year-old director, James Kirkwood, as her mother stalked the city with a pistol in hopes of interrupting their assignations; unmarried screen lovers Harold Lockwood and May Allison were said to be a bit more familiar than propriety recommended; and fan-magazine columnists warned readers that rugged he-man cowboy star J. Warren Kerrigan's best girl was his mother, even as Santa Barbara residents noticed that Jack seemed most comfortable in the company of character actor George Periolat. Still the Flying A troupe was churning out hundreds of films, and the studio paid its bills on time, which made them good citizens in the eyes of the chamber of commerce.

While the stars of the Flying A films were popular in the first decade of the 20th century, few of them would be known by even the most serious film buffs today. The names of Mary Miles Minter and Wallace Reid are familiar—hers because she was involved in the scandal and mystery surrounding the death of director William Desmond Taylor, and his because he died young from the effects of morphine addiction. Eugene Palette is remembered as the rotund, gravel-voiced comic actor prominent in such films as *My Man Godfrey* (1936) and *The Adventures of Robin Hood* (1938), and William Frawley is beloved as Fred Mertz from early television's *I Love Lucy*. But names like Margarita Fisher, William Russell, Gail Kane, and Art Acord don't generate even a

7

dim flicker of recognition today, and it is unlikely that they will ever be candidates for rediscovery since most of their films have crumbled to dust.

The lasting legacy of the American Film Company can be found in its roster of directors. No other early studio boasted such a "deep bench" of behind-the-camera talent. Allan Dwan would go on to make *Douglas Fairbanks in Robin Hood* (1922) and *The Iron Mask* (1929); Victor Fleming, who started as a chauffeur and assistant cameraman at Flying A, would wield the megaphone on *Gone With the Wind* and *The Wizard of Oz* (both 1939); Marshall Neilan would become Mary Pickford's favorite director. Frank Borzage became the master of screen romance with pictures like *7th Heaven* (1927) and *History is Made at Night* (1937); George Marshall would direct *Destry Rides Again* (1939) and *Murder He Says* (1944); Henry King would become one of the most successful box-office filmmakers of all time with hits like *State Fair* (1933), *Alexander's Ragtime Band* (1938), *Jesse James* (1939), *Song of Bernadette* (1944), *Margie* (1946), and *Twelve O'clock High* (1949).

In its short 11-year history, the American Film Company produced around 1,200 films. Only about 100 are known to survive today, scattered in established film archives and private collections. Most of these films were one- and two-reel short subjects designed for the nickelodeon market before feature-length films became the established norm. There was a sameness to many of these early pictures. They were based on the theatrical stock company tradition in which a small group of actors would appear together week after week in stories tailored to their stereotyped personas—a hero and a leading lady, a "dress heavy" and a henchman, an ingénue and a juvenile, a character man and a character woman. It would be hard to make a case that our understanding of the art of cinema would be greatly changed if all these movies had survived. But, as the stills in this book amply demonstrate, plot is not always the most interesting thing about a film. In these now-lost films, a young lady in a harem skirt might still catch our eye, and young men would dress in cutaway coats and top hats to go about their daily business. Stutz Bearcat roadsters would chew up the road and steam trains thunder down the rails. A vanished landmark could be seen, such as Santa Barbara's famed Potter Hotel or the Mission before it was damaged and rebuilt after the 1925 earthquake; the artist Frederick H. Rhead might still sit at his potter's wheel, molding jars from wet clay; and the past might briefly live again.

One

AMERICAN BORN

The origin of the American Film Manufacturing Company can be traced to the dawn of the nickelodeon era when Chicago businessmen Samuel S. Hutchinson and Charles J. Hite established H and H Film Service in 1906. The film rental exchange bought films from such established film producers as Thomas A. Edison, Inc., American Mutoscope and Biograph Company, Vitagraph Company of America, and the Selig Polyscope Company and rented them to theaters throughout the Midwest. The movie craze was sweeping the country, and soon new producers like the Kalem Company and the Essanay Film Manufacturing Company entered the field, and H and H Film Service reaped big profits.

In an effort to control the motion-picture industry, the leading film companies formed the Motion Picture Patents Company in 1908, which established a monopoly based on the pooled patent rights controlled by the various member companies. Two years later, the Patents Company formed the General Film Company to act as a common distributor for the producers and sought to buy up the most successful independent film exchanges and force smaller exchanges out of business by cutting off their supply of films.

H and H had a choice: sell out, be starved out, rely on the trickle of films being turned out by foreign studios and the few independent producers defying the Patents Company, or become an independent producer. S. S. Hutchinson opted to start his own production company.

Nicknamed the "Flying A" because of its winged "A" logo, Hutchinson's new American Film Manufacturing Company raided the Chicago-based Essanay Film Manufacturing Company, hiring its leading actors and technical staff, and sent its new employees to rural Illinois to make its first film, a Western titled *Romantic Redskins*, which was released October 29, 1910.

Essanay and the Motion Picture Patents Company were outraged, and while the American Film Manufacturing Company would maintain its home office in Chicago, Hutchinson felt it would be the better part of valor to send his production unit to California for the sunshine and the scenery—and to evade the armed thugs the Patents Company hired to shut down the upstart Flying A.

American Film For the American People

After several weeks of teaser announcements, a full-page advertisement in the October 8, 1910, issue of *The Moving Picture World* proclaimed the formation of the American Film Manufacturing Company and announced, "Every man in our organization has had from two to five years experience in film making." All the announced personnel were hired away from the Essanay Film Manufacturing Company, a Chicago rival established in 1907.

Chicago-area independent film exchange operator Samuel Sheffield Hutchinson founded the American Film Company to keep a steady flow of films coming to his film-rental business after the Motion Picture Patents Company threatened to cut him off from the product of its member producers. Little is known about Hutchinson, who may have been English by birth and has been variously described as a former pharmacist or a former banker.

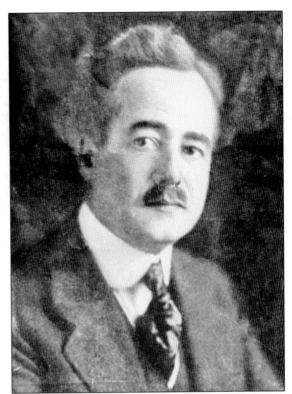

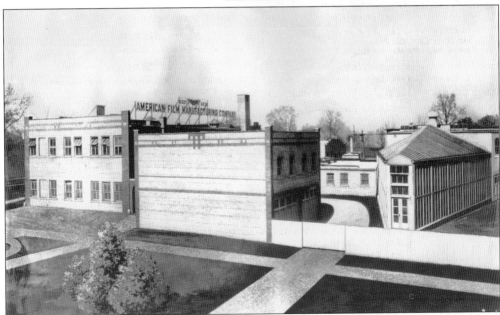

The American Film Manufacturing Company plant was located in Chicago at 6227-35 Broadway. Although it had a small glass stage, the Chicago plant was rarely used for picture making. The offices of S. S. Hutchinson, general manager R. R. Nehls, and technical manager Charles Ziebarth were here, as were the film laboratory where American made its release prints, the film vaults, and the projection rooms for trade screenings.

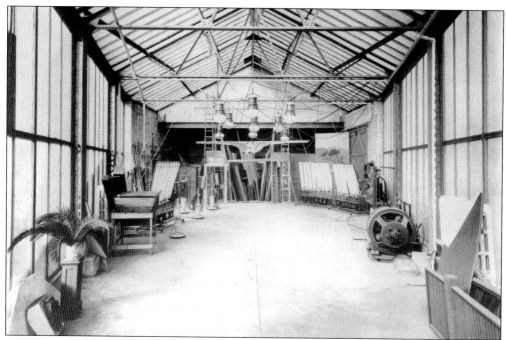

Initially the Flying A maintained two units in Chicago—a dramatic company under the direction of Thomas Ricketts and a comedy company under the direction of Sam Morris, both of which used this tiny glass stage. A third unit, under the direction of Frank Beal, was sent to Southern California to shoot Westerns. It was the cowboy pictures that clicked with the public, and the Chicago units were soon abandoned.

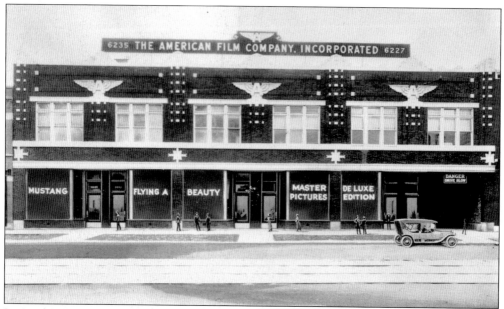

In April 1915, the American Film Company began work on a $200,000 expansion of its Chicago headquarters. Several of the earlier buildings on the site were moved to the back of the lot to make way for a new administration building, seen here in an architect's rendering. The brick and terracotta structure was two and a half stories tall with an area of 9,000 square feet on each floor.

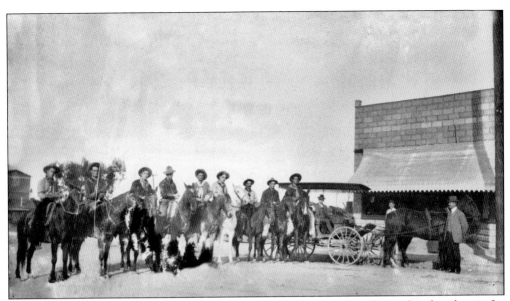

The Flying A Western company established a base of operations in a former butcher shop in La Mesa, California. Here S. S. Hutchinson (standing at right) pays a visit soon after the company settled. Business manager Wallace Kerrigan stands behind the horse in front of the store, and his brother and the company's star, J. Warren Kerrigan, is astride the white horse.

When the Western unit stopped sending films to Chicago, S. S. Hutchinson sent scenario editor Allan Dwan (1885–1981) to California to see what was causing the delay. He found the unit on location in San Juan Capistrano, but director Frank Beal was off on a bender. Dwan wired Hutchinson: "SUGGEST YOU DISBAND COMPANY YOU HAVE NO DIRECTOR." Hutchinson replied: "YOU DIRECT." Dwan told the stranded actors, "Either I'm a director—or you're out of work."

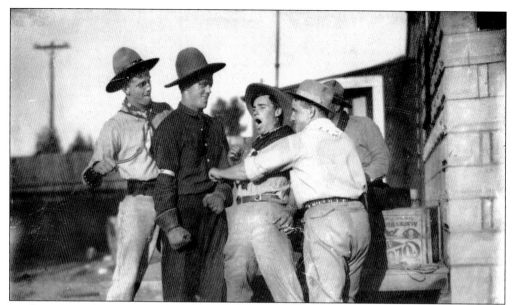

Dwan was accepted as the new director of the Western unit, and here he clowns around with some of the Flying A cowboys in the side yard of the La Mesa offices. Nearly all the films Dwan shot in La Mesa were made outdoors without any interior sets. The Flying A Western unit would spend a year in La Mesa and Lakeside, California, before moving to Santa Barbara.

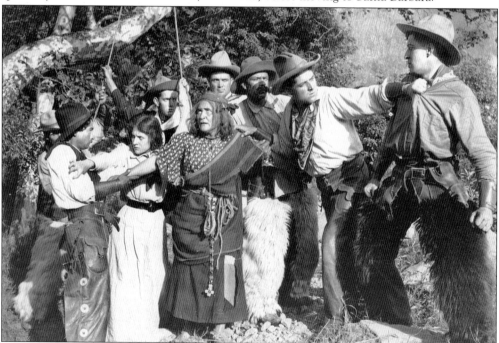

Typical of the films Allan Dwan made in La Mesa was *The Witch of the Range*, released June 12, 1911. Louise Lester (wife of indisposed director Frank Beal) plays the witch. Pauline Bush and J. Warren Kerrigan rescue her from a necktie party as Kerrigan grabs villain Jack Richardson by the throat. Dwan produced one-reelers like this at the rate of one a week, and they proved so popular he was soon making two—and later three—weekly.

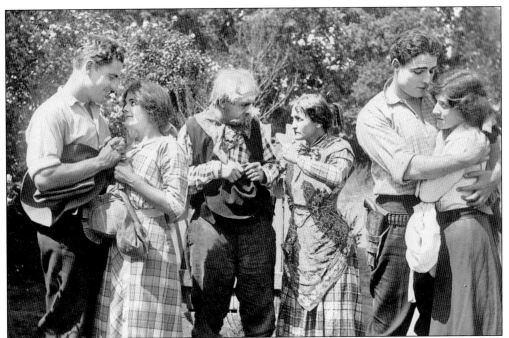

Seen from left to right are juvenile Marshall Neilan, ingénue Jessalyn Van Trump, character man George Periolat, character woman Louise Lester, leading man J. Warren Kerrigan, and leading woman Pauline Bushin the denouement on an unidentified 1911 Flying A Western romance. Early filmmakers followed the long-established theatrical practice of tailoring their stories to a stock company of well-defined types.

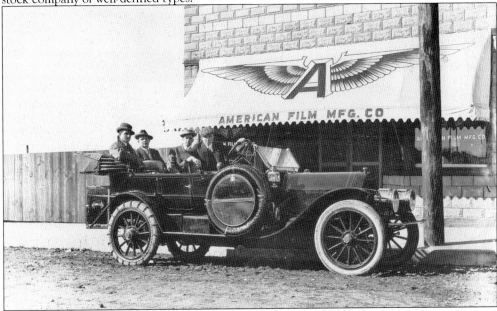

The Flying A logo has been painted on the awning of the former La Mesa butcher shop as Allan Dwan prepares to drive several of his actors to location in the studio car. Pictured from left to right in the car are J. Warren Kerrigan, George Periolat, Jack Richardson, and Dwan. The trunk strapped to the back of the car carries all the company's film stock and camera equipment.

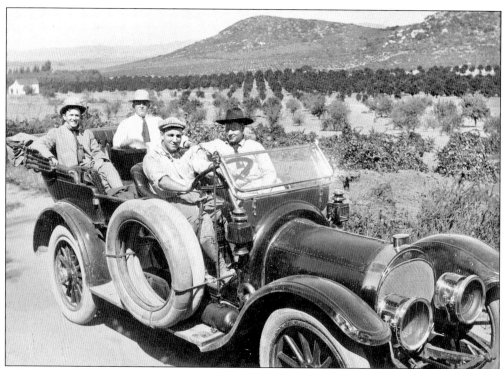

Allan Dwan (at steering wheel), cameraman Roy Overbaugh (back seat, left), and two unidentified passengers take a spin through citrus groves near La Mesa, California, in 1911. The car is a French-made Delaunay-Belleville, noted for its distinctive round radiator.

Allan Dwan was such a fast director that he could often turn out a complete one-reel film in three or four hours and then end the workday with a late lunch. Pictured from left to right are J. Warren Kerrigan, George Periolat (partially obscured), Allan Dwan, Jack Richardson, unidentified player, Pauline Bush, cameraman Roy Overbaugh (standing), and another unidentified player.

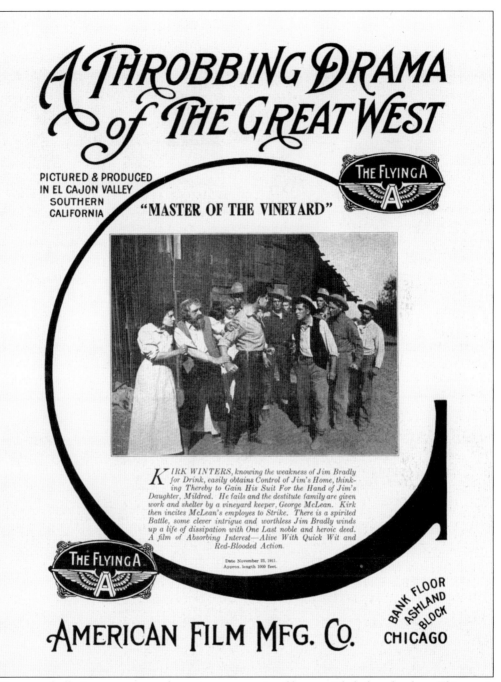

One-page bulletins were prepared to announce coming films to nickelodeon bookers. This one is for *Master of the Vineyard*, released November 23, 1911. One of the selling points of the film was that it was "Pictured and Produced in El Cajon Valley Southern California."

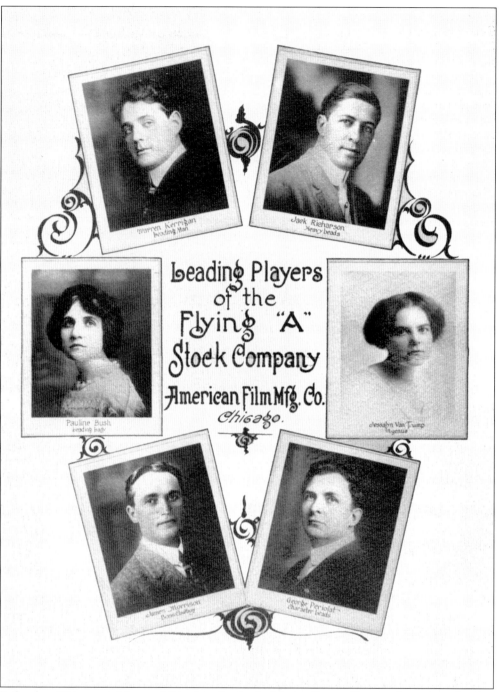

Leading Players
of the
Flying "A"
Stock Company
American Film Mfg. Co.
Chicago.

Before late 1911, most of the established studios in the Motion Picture Patents Company refused to advertise the names of players in their films, believing it would lead to an escalation in salaries for their most popular actors. The Flying A made a point of promoting its stars from the beginning. This is an early "giveaway" for fans who wrote asking for pictures of their favorites. Pictured clockwise from top left are J. Warren Kerrigan, Jack Richardson, Jessalyn Van Trump, George Periolat, James "Chick" Morrison (the studio's top wrangler), and Pauline Bush.

The Kerrigan brothers both worked at the Flying A. George Kerrigan (1879–1947), nicknamed "Jack" and known professionally as J. Warren Kerrigan, was voted the most popular movie player by readers of *Photoplay* magazine in 1912. While not openly gay, it was no secret to his coworkers that he preferred the company of men, and fan-magazine writers peppered their stories about him with phrases like "his best girl is his mother" or "don't get your hopes up girls" or "he likes girls well enough in a crowd."

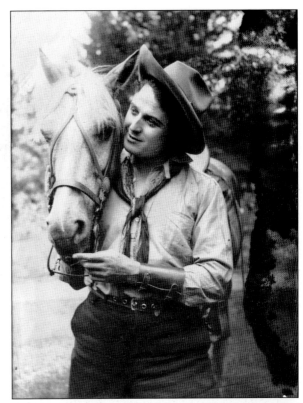

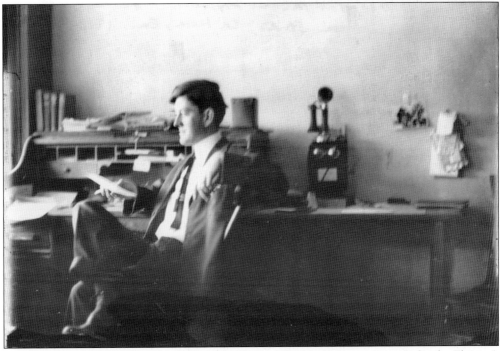

Jack Kerrigan's younger brother, Wallace Kerrigan, served as business manager for the Flying A Western unit. Wallace is seen at his desk in the La Mesa headquarters.

Actor Marshall Neilan was sent on a scouting mission by director Allan Dwan to find a new place for the Flying A to set up shop. He reported that Santa Barbara would be the ideal location. Neilan would later go behind the camera and become a top Hollywood director.

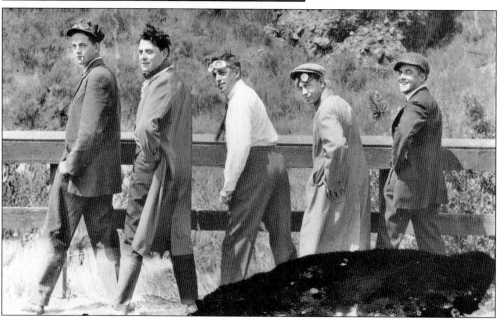

"The Pee Parade," a gag shot, was taken during the company's three-day journey to Santa Barbara in July 1912. The envelope that enclosed the glass-plate negative warned "Not for Chicago," meaning the home office was not to see it. By the time it was printed in the early 1970s, water damage had degraded the image. Pictured from left to right are company chauffeur Pete Morrison, J. Warren Kerrigan, Jack Richardson, Roger Armstrong, and Marshall Neilan.

Two

WHERE DESTINY GUIDES

By early 1912, director Allan Dwan felt that the Flying A had used up all the scenery around La Mesa, and he sent his assistant, Marshall Neilan, to scout for potential sites where the company might resettle. Los Angeles was already a major production center, and Patents Company members Selig, Vitagraph, Kalem, and Biograph had branch studios in Los Angeles.

Neilan reported that Santa Barbara was the ideal location. It had all the scenic advantages Dwan desired, offered railroad access to the rest of the country, and provided a 90-mile buffer from Patents Company units in the City of Angels.

Although the Flying A films were popular with audiences, distribution was unreliable in its first year of operation. However, in 1912, the American Film Manufacturing Company signed a contract with the newly formed Mutual Film Corporation to distribute its product. Headed by Harry Aitken, Mutual also released the films of the Thanhouser Film Company, headed by S. S. Hutchinson's former partner, Charles J. Hite; the New York Motion Picture Company, producers of the Broncho, Keystone, Domino, and KayBee brands; and the American branch of the French company Gaumont. The alliance with Mutual provided economic stability and allowed the Flying A to expand production.

Whether Dwan intended to make Santa Barbara the final stop for American's Western unit is unclear. It was common for early film companies to pull up stakes and relocate on a regular basis. But production demands ultimately forced the company to stay put and establish more permanent studio facilities. To meet the demand for Flying A films, Dwan established a second unit with Wallace Reid as its star. J. Warren Kerrigan resented the company's second leading man and demanded that the second unit be abandoned. Allan Dwan held his ground, but S. S. Hutchinson sided with Kerrigan, shut down the second unit, and fired Dwan and Reid.

The director signed with the Universal Film Manufacturing Company in Hollywood. Ironically, Kerrigan was also soon lured away by Universal, and Hutchinson was forced to quickly rebuild his company from scratch.

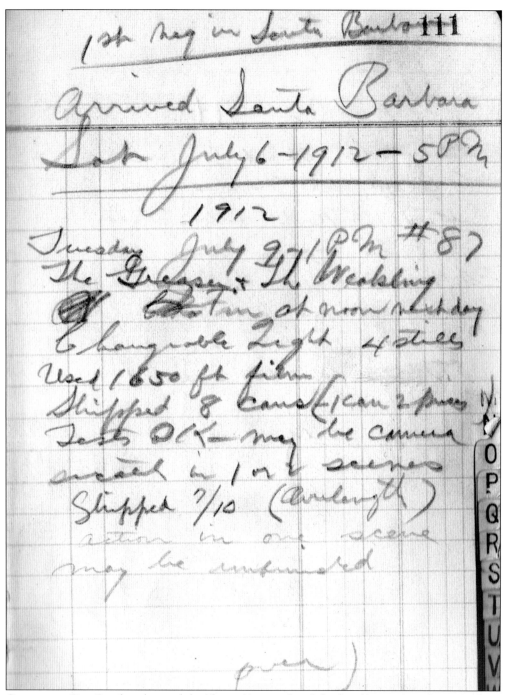

Cameraman Roy Overbaugh noted the Flying A's arrival and the first film made in Santa Barbara in his production diary: "Arrived Santa Barbara Sat July 6—1912—5 PM—Tuesday July 9—1 PM [production] # 87 The Greaser and the Weakling Fin[ished] at noon next day. Changeable Light. 4 stills [shot] used 1650 ft. film Shipped 8 cans (1 can 2 pieces) Tests OK—may be camera scratch in 1 or 2 scenes. Shipped 7/10 (over length)." With the Mexican revolution raging south of the border, Mexicans became common villains in films of the early 1910s.

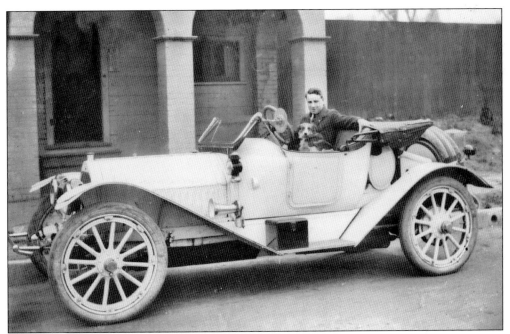

Allan Dwan, shortly after the Flying A company arrived in Santa Barbara, parked in front of the abandoned ostrich farm on State Street near Islay, which became the company's first Santa Barbara studio. Ostrich plumes had been deemed a necessary adornment on ladies' hats in past seasons, but by 1912, the craze had peaked. The facility had a small office building and a large fenced-in yard that could be used as production space.

Pictured from left to right are director Allan Dwan, scenario writer and second cameraman Roger Armstrong, and scenery and property man Sid Baldridge in the backyard of the ostrich farm studio in 1912. Although Dwan continued to shoot most of his pictures on location, the new larger studio led Dwan to attempt some more ambitious productions, and Baldridge brought his experience as a stage carpenter to the company.

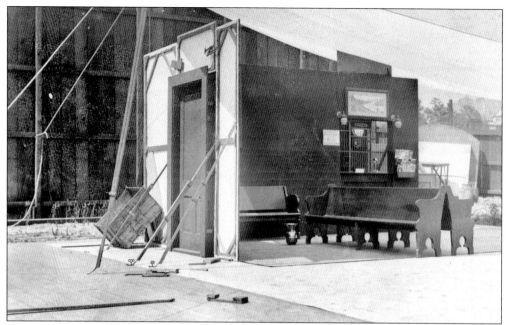

This train-station interior was the first setting built by Sid Baldridge at the ostrich farm studio. This sort of two-walled set was common in the nickelodeon era, when each scene was generally played in a single take from a fixed camera position, and there was no need to build anything the camera wouldn't see. The crude muslin drape overhead diffused the sunlight and created a more realistic sense of interior lighting.

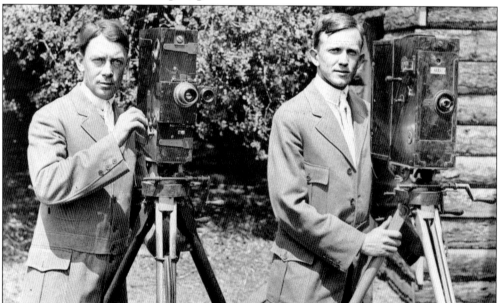

Flying A cinematographers Roger Armstrong (left) and Roy Overbaugh pose with their British-made cameras. Although Thomas Edison claimed patents on basic motion-picture-camera and projection technology and sought to monopolize film production by enforcing his claims through the Motion Picture Patents Company, he never registered for European patents, and independent filmmakers took advantage of this loophole by using foreign-made equipment.

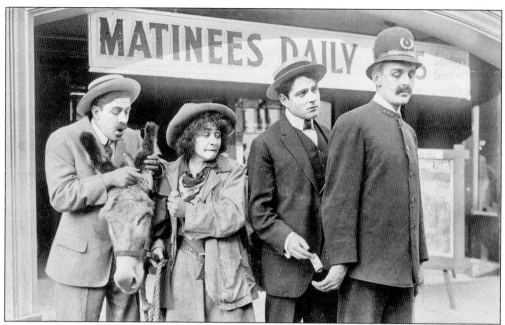

Even after they moved to Santa Barbara, the Flying A would occasionally go on location. In *Calamity Anne Takes a Trip* (released June 26, 1913) the rough-hewn cowlady made her way to Santa Monica, where she went to the amusement pier and this nickelodeon. From left to right are Jack Richardson, Louise Lester as Calamity Anne, J. Warren Kerrigan, and Wallace Reid as a bribe-taking cop. Kerrigan preferred to see Reid in bit parts like this.

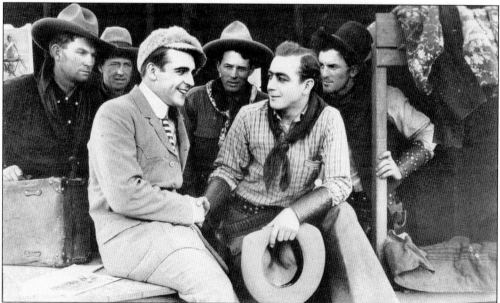

Director Allan Dwan set up a second unit with Wallace Reid as leading man. One of the Reid films was *When Jim Returned* (released April 24, 1913). Reid (in suit) comes back to the ranch where he will soon be the rival of Eugene Pallette (right) over the affections of the rancher's daughter. Reid became a star at Paramount in 1915. Pallette gained fame as a heavyset, gravel-voiced character actor in the 1930s.

After S. S. Hutchinson fired Allan Dwan for setting up the Wallace Reid unit, he hired director Lorimer Johnston (1858–1941) from the Selig Polyscope Company, a rival Chicago studio. Johnston had a long career as a stage and screen actor before he took up the megaphone. His career as a director ended in the early 1920s, after which he returned to acting, appearing in character roles up to the time of his death.

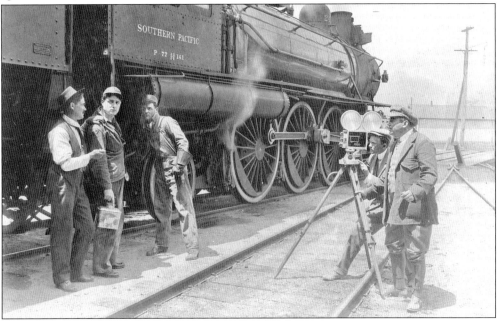

Lorimer Johnston (right) directs one of his first Flying A films, *Tom Blake's Redemption* (released July 24, 1913). Here Chick Morrison (with mustache) chastises J. Warren Kerrigan for being late. Cameraman Roy Overbaugh shoots the film with a new Bell and Howell model 2709 camera. Manufactured in Chicago, the number refers to the date of the Bell and Howell prototype—February 7, 1909—but production models were rare before 1912.

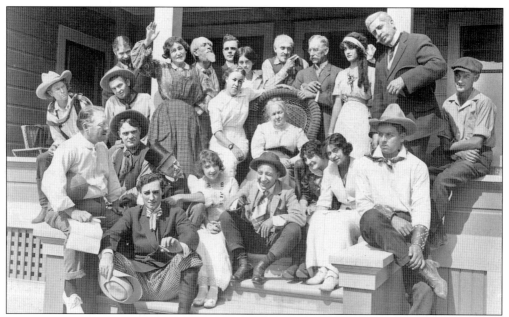

Pictured is the home of Peverel Meigs on Cliff Drive, near the city limits. Meigs founded El Montecito Manufacturing Company. Included from left to right are (seated) Lorimer Johnston (holding script), Chick Morrison, Sydney Ayres (hat in hand), unidentified, Violet Knight, William Tedmarsh, Carolyn Cooke, Charlotte Burton, and Manuel Sampson; (second row) Louise Lester (in apron) and the daughter and the wife of Peverel Meigs (on chair); (behind chair) Leontine Birabent, Harry von Meter, Peverel Meigs, Vivian Rich, and Jack Richardson.

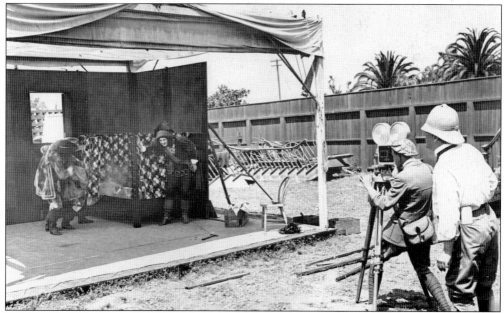

At work on the small outdoor stage at the ostrich farm studio shooting *The Adventures of Jacques* (released August 11, 1913). Lorimer Johnston (in pith helmet) directs; Roy Overbaugh cranks the Bell and Howell camera. J. Warren Kerrigan plays Jacques. Note the string outline on the floor of the crude stage that marks the range covered by the camera's lens.

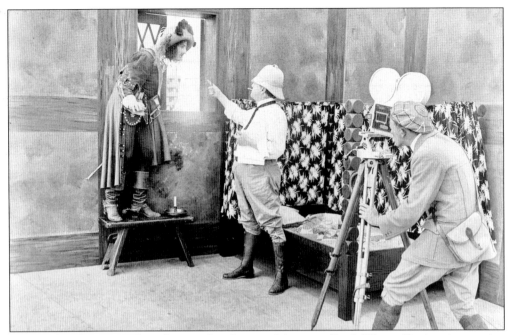

Roy Overbaugh moves in for a closer angle as Lorimer Johnston offers J. Warren Kerrigan instruction on the scene. Note the stagehands holding a reflector outside the window to give Kerrigan a strong back light. Breaking up a scene into multiple shots was still relatively unusual in 1913, and this sequence of photographs offers a rare glimpse of an early advance in film technique.

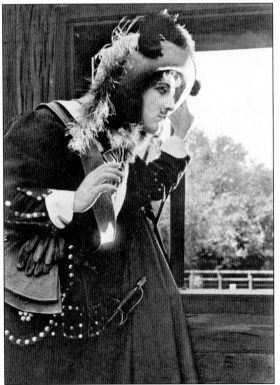

J. Warren Kerrigan's close-up is shown as it appeared on screen. In *The Adventures of Jacques*, Jacques le Grand, a young Gascon noble, rescues Constance, a lady-in-waiting who has been confined in a tower by order of the queen. The resemblance to *The Three Musketeers* was no doubt intentional. Pressed to come up with new ideas at the drop of a hat, early filmmakers took their inspiration wherever they could find it.

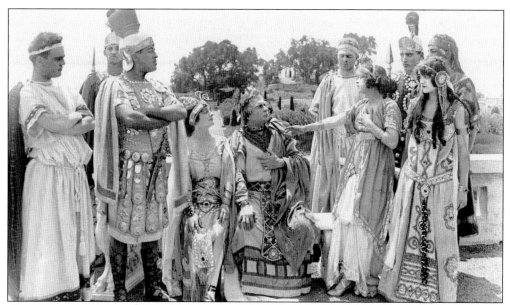

The William Miller Graham estate on Booth's Point, with its classically influenced architecture, formal gardens, and reflecting pools, served as a backdrop for a number of Flying A films. Budgets in 1913 were $500 to $800 per reel of finished film, and there was no money to build extravagant sets, so filmmakers made do with available buildings. Pictured in the foreground from left to right are Charles Cummings, Jack Richardson, Carolyn Cooke, George Periolat, Charlotte Burton, and Vivian Rich.

The cast and crew of *In the Days of Trajan* (released October 27, 1913) at the William Miller Graham estate are, from left to right in the foreground, assistant director Jacques Jaccard, director Lorimer Johnston, Carolyn Cooke (Mrs. Lorimer Johnston), George Periolat, J. Warren Kerrigan, Vivian Rich, Jack Richardson, and Charlotte Burton. Future director B. Reeves "Breezy" Eason is fifth from left at the railing above.

In the Days of Trajan features emperor Trajanus (George Periolat) and empress Pompeia Plotina (Carolyn Cooke) demanding that the defeated Decebalus, Prince of Dacia (J. Warren Kerrigan), and his mother, Queen of Dacia (Louise Lester) swear allegiance to Rome. The queen replies, "In Dacia we are royal and shall not be vassals to Rome." Octavia (Vivian Rich, behind Kerrigan) and a Roman general (Jack Richardson, right) look on.

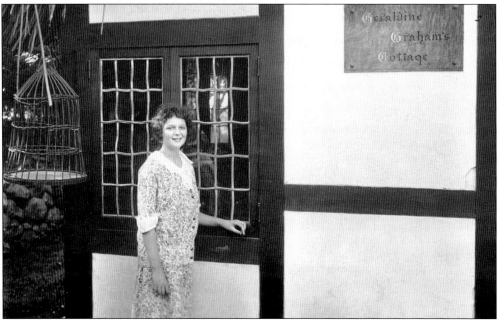

Geraldine Graham, daughter of William Miller Graham, had her own small house, though it was influenced more by Tudor than classical Revival style. To leave no doubt in the minds of all who entered, a plaque proclaimed: "Geraldine Graham's Cottage."

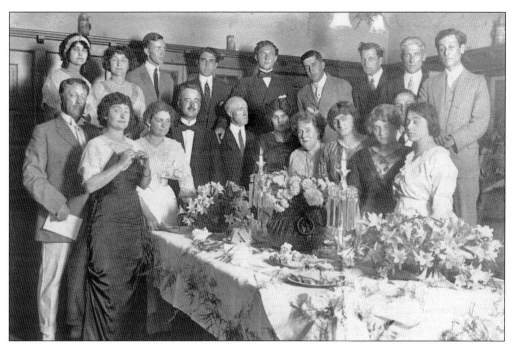

At a party in the Santa Barbara home of studio head S. S. Hutchinson are, from left to right, (first row) director Lorimer Johnston, Carolyn Cooke, Mrs. Hutchinson, S. S. Hutchinson, director Thomas Ricketts, Ethel Ricketts, Ida Lewis, Mrs. Von Meter, Winifred Greenwood, and Charlotte Burton; (second row) Vivian Rich, Louise Lester, B. Reeves Eason, Harry Von Meter, Sydney Ayres, Jack Richardson, Edward Coxen, studio general manager P. G. Lynch, and George Field.

Sydney Ayres starred in *The Story of the Olive* (released May 6, 1914). Ayres (1879–1916) was a popular West Coast theater leading man before he entered movies in 1910. He signed a one-year contract with the Flying A in 1913. Marjorie Overbaugh recalled that Ayres was "crazy," but this may have been due to the early effects of multiple sclerosis, which took his life at age 37.

The Story of the Olive (released May 6, 1914) offered an odd blend of drama and actuality. Set in 1840, the story revolved around an American (played by Sydney Ayres, center) who offers to buy the California land-grant estate of Don Jose de Cabrillo (Harry Von Meter) after he receives a tour showing how the olive industry works, from picking to olive-oil pressing. The daughter Mercedes (Vivian Rich) does not want to lose the family rancho.

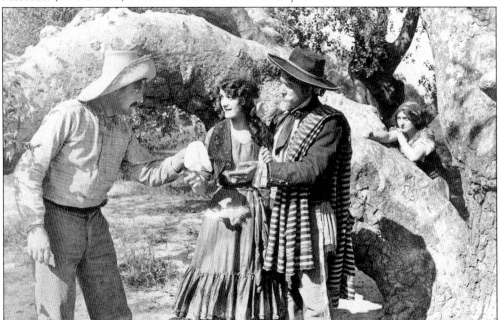

The unscrupulous foreman Ortega (Jack Richardson) in *The Story of Olive* later robs Don Jose of the gold from the sale of the rancho. His jealous lover (Carolyn Cooke) looks on. When Ortega refuses to share his ill-gotten gains, he is crushed in the olive press by his henchmen.

The Last Supper (released April 13, 1914) was a modern-day story about a man who walks in Christ's shoes and sets an example for those with whom he comes in contact. Sydney Ayres starred as the mysterious stranger and also directed.

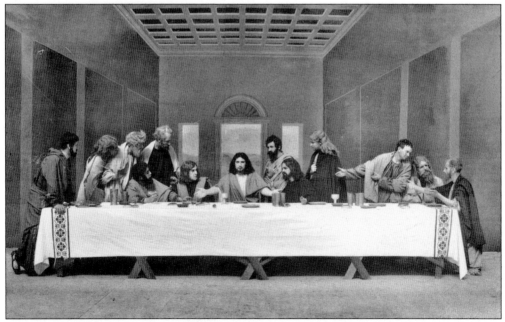

The two-reel *The Last Supper* was filled with religious imagery, including a scene in which Ayres walked on water with the aid of double-exposure photography and a scene in which the 13 guests at a formal dinner party were transformed into an image of the last supper. Cameraman Roy Overbaugh was especially proud of his re-creation of the Leonardo da Vinci painting.

Using Santa Barbara's bicentennial celebration of the birth of Fr. Junipero Serra, founder of the California missions, as a jumping-off point, the American Film Manufacturing Company produced *The Coming of the Padres* (released March 18, 1914). This awkwardly played scene, directed by Lorimer Johnston, featured, from left to right in the foreground, Sydney Ayres, Vivian Rich, Jack Richardson, Carolyn Cooke, Louise Lester, and Charlotte Burton. The location is Casa de la Guerra in the first block of East De La Guerra Street.

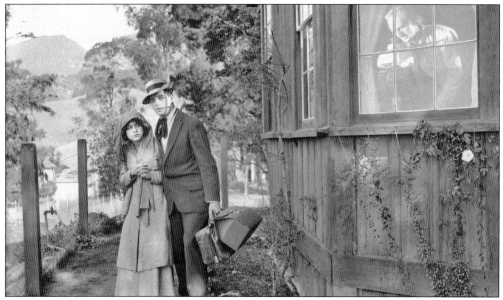

In the Firelight (released December 29, 1913) was based on a story by Marc Edmund Jones and was directed by Thomas Ricketts. Jones lived in Santa Barbara from 1908 to 1911, working as manager of Western Machine and Foundry. After moving to Chicago, he supplemented his income by writing movie scenarios. He later became a noted advocate of astrology. Here Charlotte Burton and Edward Coxen play the eloping couple. William Bertram lights the lamp at the window.

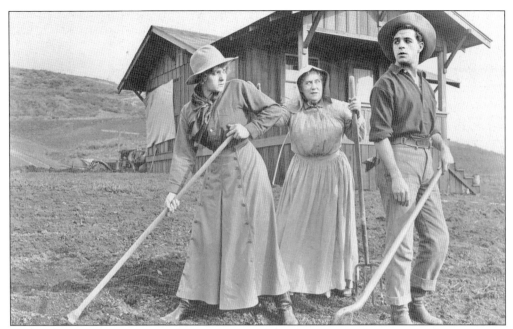

The Independence of Susan (released April 15, 1914) featured Winifred Greenwood (left) as Susan, a character who homesteads her property and resents the advice of her neighbor, John (Edward Coxen). Susan learns her lesson when her head is turned by a handsome stranger and she is forced to rely on John to save her property. Ida Lewis is also in this scene.

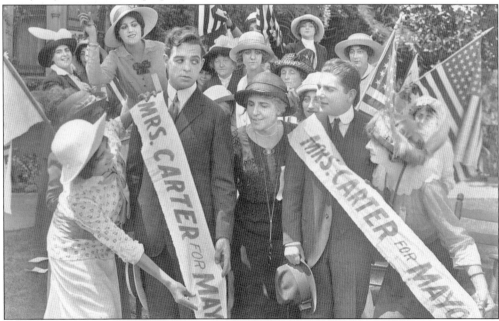

Mrs. Carter's Campaign (released September 25, 1913) was a convoluted comedy about municipal politics. When the mayor spurns the efforts of the Clean City Club, Mrs. Carter becomes a candidate. Her daughters call off their engagements to Tom and Dick, on the mayor's staff, and refuse to marry unless their mother wins. The men urge the male voters to bet on the election, which disqualifies their votes and leads to Mrs. Carter's victory.

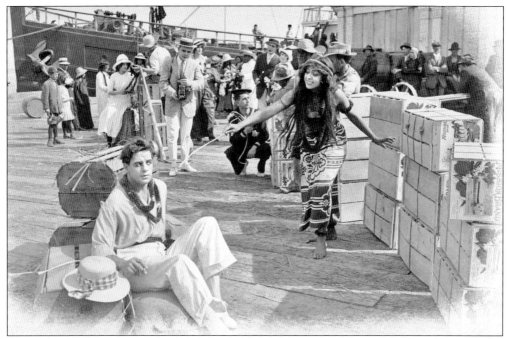

A Soul Astray (released May 11, 1914) featured Edward Coxen as a white man who goes native and Charlotte Burton, with the aid of some "bolemany" (Bole Armenia, a skin darkening makeup), as a native girl. Director Thomas Ricketts made the Santa Barbara pier and beach look like the South Seas, and *Moving Picture World* commented on the "considerable Hawaiian atmosphere" in the film, though the fruit crates on the pier bound for the mainland bear labels proclaiming: "Mission Brand—Johnston Fruit Company, Santa Barbara, California." Like Los Angeles, Santa Barbara offered varied scenery, which made it an ideal studio site. But, because other studios did not locate there, the pool of acting and behind-the-scenes talent was more limited than in Hollywood.

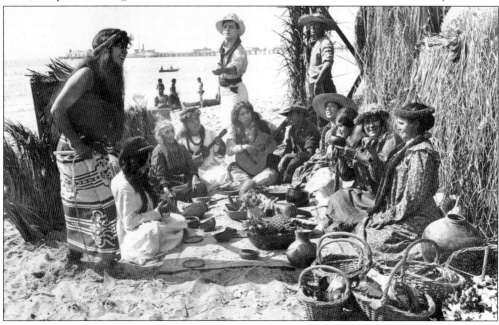

Three

DREAMS REALIZED

By mid-1913, the Flying A decided to establish a permanent studio in Santa Barbara. Two square blocks of land were acquired on west Mission Street, between State Street on the east, Chapala Street on the west, and Los Olivos Street on the north, and plans were drawn in the Mission Revival style.

As planned, the new lot would include offices for writers and directors, dressing rooms for the leading players, an administrative building with cutting rooms and a projection room, a machine shop, and a glass stage for year-round filmmaking.

Expanding production schedules made the new studio inadequate almost from the beginning. Additional property was acquired several blocks away, where the Flying A built a Western street and additional outdoor stages. The "big glass" stage, built on the main lot and completed in 1915, could accommodate several units working side by side at the same time.

The years between 1913 and 1916 were the company's most successful. Production was geared toward making short films that were distributed through the Mutual Film Corporation as part of a program for theaters that changed bills two or three times a week and sometimes as often as every day.

But the picture business was changing, and audiences became eager to see feature-length films. The world war that started in August 1914 also affected the company. The Flying A had a well-established sales network in Europe with primary offices in London, and a good portion of the company's income came from overseas sales.

Initially the war had little impact on the company because the United States remained neutral; in fact, foreign sales increased for a time. But it was difficult to ignore the demand for feature films. At first, Mutual had no adequate way to distribute features, which could cost as much as 15 times what a one-reel short might cost. The Flying A attempted to meet market demands by turning out three-reelers—films that it hoped would satisfy the demand for longer films and still be economical enough to be released on the regular Mutual program.

In mid-1913, construction began on a new studio on Mission Street. The lot consisted of two square blocks, but permanent buildings were only erected on the block fronting Mission Street. The back lot was to accommodate outdoor sets, but it soon became built up with ramshackle stages and outbuildings. Visible in the distance is St. Anthony's Seminary, which was destroyed in the 1925 Santa Barbara earthquake and later was rebuilt.

The "green room," seen here from the exterior, was a den-like room with a fireplace and chairs where actors could wait for their call, study scripts, and receive visitors. Most of the surviving photographs of the Flying A studio date from 1916, but this image was shot in 1913, soon after the new buildings were completed.

The grounds are seen from the administration building's tower. The formal garden to the left was designed to add beauty and serve as a setting for the company's new line of "society" pictures, which were intended to satisfy a movie market that was becoming oversaturated with Westerns.

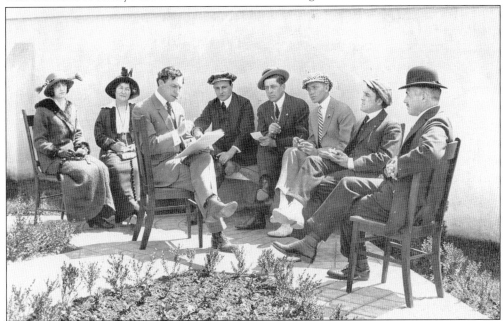

The Santa Barbara climate was so pleasant that it seemed a shame to stay indoors. This is a 1914 story conference in the formal garden. Director Sydney Ayres goes over a script with, from left to right, Vivian Rich, Louise Lester, William Garwood, Jack Richardson, assistant director B. Reeves Eason, Harry Von Meter, and studio head S. S. Hutchinson. Contrary to the notion that early filmmakers worked "off the cuff," written scripts were the rule.

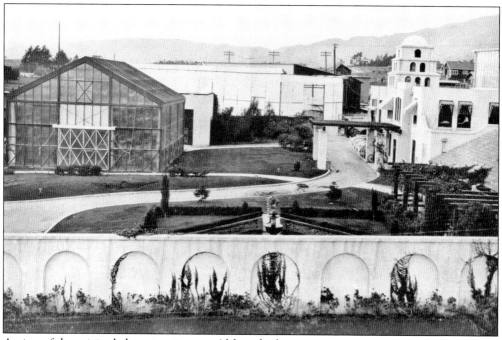

A view of the original glass stage is seen. Although glass stages were common in the East where weather was less predictable, they were more unusual in West Coast studios, where outdoor stages and "dark" stages were favored. A long row of outdoor stages with diffusers is behind what became known as the "small glass" stage.

A detail of the small glass stage shows director Murdock MacQuarrie (wearing cap) going over a script with an unidentified associate. The small glass stage featured panels of "pebble glass," which had diffusing properties to soften the harsh sunlight, but from this photograph, it is clear that muslin drapes provided additional diffusion. Like many early film directors, MacQuarrie (1878–1942) ended his career playing bit parts in "poverty row" pictures.

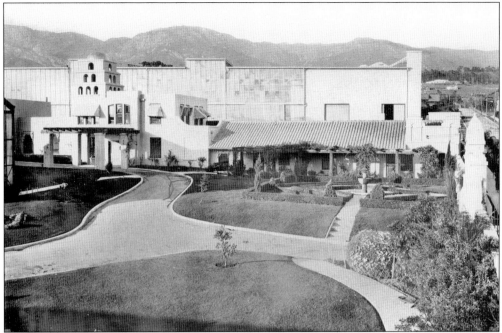

This view looks east from the roof of the green room. The long building with the Spanish-tile roof housed the studio reception area and offices for writers and directors. The administration building and camera department is in the Mission-inspired building. The big glass stage, completed in 1915, is behind the office buildings.

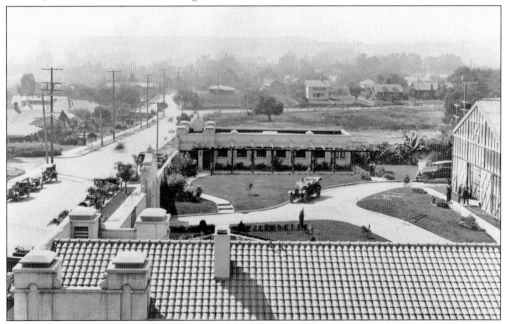

This view looks west from the roof of the big glass stage, showing the green room and dressing rooms in the background. The area behind the dressing rooms was originally planned to be a jungle lagoon that could serve as a backdrop for exotic scenes, but the space was not large enough to provide a credible jungle setting.

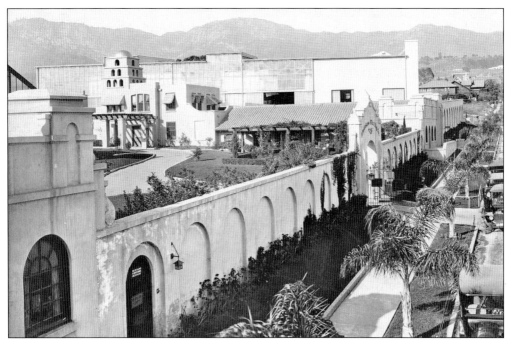

This shot was taken in 1915, after the completion of the big glass stage but before the company changed its corporate name. The sign above the front gate reads, "American Film Manufacturing Company." This was replaced with a new sign that simply said "American Film Company" in 1916.

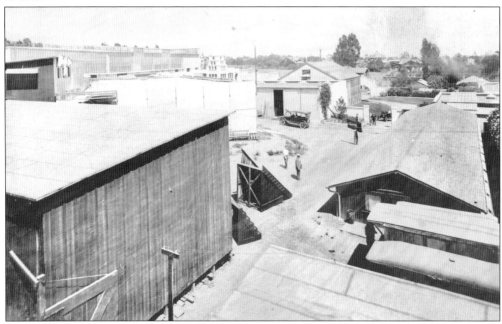

The back-lot buildings at the Flying A studio were considerably less impressive than the ones fronting Mission Street. A row of open-air stages runs at an angle behind the small glass stage with a large storage shed and additional dressing rooms for bit players and extras behind it. Additional offices were located in the long building at the right.

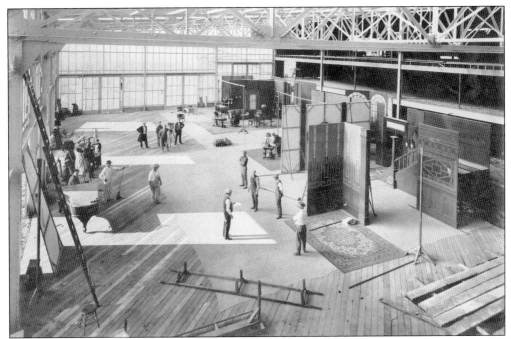

A view inside the big glass stage looks north from the elevated storage deck at the south end of the stage. Because the films were silent, it was possible for several production units to work side by side without disturbing each other. Cinematographer L. Guy Wilky stands leaning against the Bell and Howell camera on the stage floor at middle left.

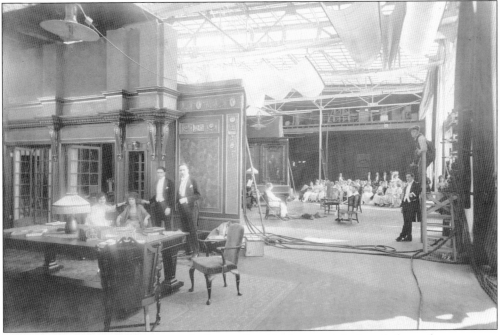

This view inside the big glass stage looks south, with the scene dock and elevated storage area in the background. Although sunlight was still the primary source of lighting, electrical cables stretched across the floor show that artificial lighting was also being utilized.

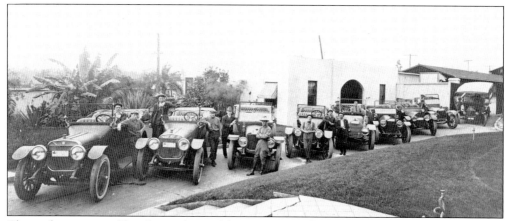

The studio motor pool lined up in front of the commissary, located behind the dressing rooms on the west side of the lot. According to a 1916 *Picture Play* magazine article by Robert G. Duncan, "It is really quite a lunch room. . . . There are about five waitresses, all dressed in white uniforms, and, I was told, a like number of men cooks—all of whom are French."

Director King Vidor recalled that when he first came to Hollywood in the late 1910s, the studio gates were just as difficult to crack as they were later. Here is a view of the studio as tourists saw it. This is a snapshot looking east from De La Vina Street. The open-air stages to the left had a solid roof by that time, and the roof of the small glass stage was painted black.

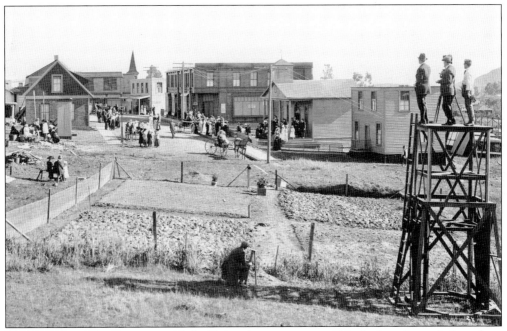

The American Film Company added additional property several blocks from the main lot, where they built the standing sets they needed for their pictures. This small-town scene dates from about 1916. The director and cameraman are on the high parallel at the right. Such platforms were common in the days before camera cranes.

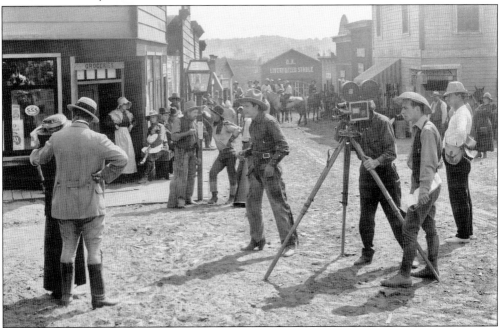

On the Flying A Western street in 1916, actor-director Frank Borzage prepares to enter scene from camera right. L. Guy Wilky cranks the Bell and Howell camera as assistant director Park Frame (in coolie hat, holding script) looks on. Frank Borzage (1893–1962) came to the Flying A in 1915 to star in Beauty brand comedies and was made a director in December of that year.

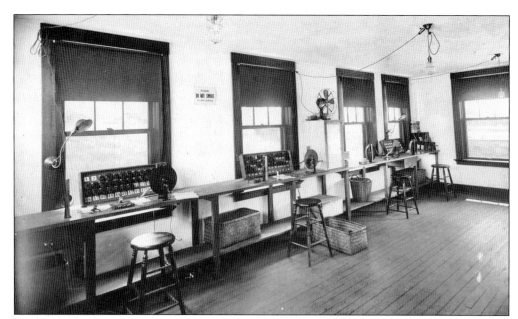

The Flying A editing rooms were in a wing that projected east behind the administration building. Here the editing room is seen in 1913.

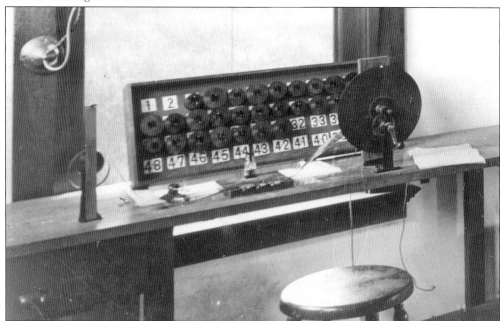

The editing process is seen here in closer detail. In the early days, each scene was staged in a single take, and numbered shots were lined up in order on a pegboard to be assembled in running order. When the company arrived in Santa Barbara, the undeveloped negatives were shipped to Chicago for processing and then returned to the coast for editing. The cut negatives were then sent back to Chicago for release printing. After the laboratory was built, negatives were developed in Santa Barbara, and in 1916, the lab installed a Bell and Howell printer to make work prints, saving wear on the original camera negative. However, throughout its history, the company made release prints in Chicago.

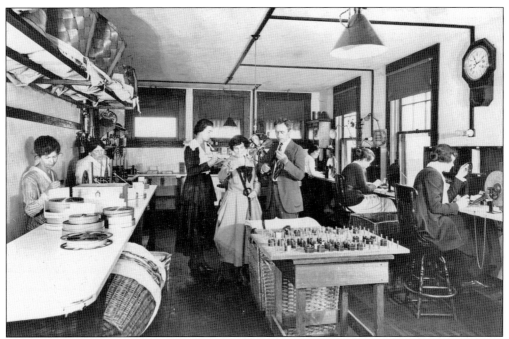

The editing room is shown in 1916, at the height of the studio's success. All of the editors were women, not an unusual circumstance in the second decade of the 20th century. Pictured from left to right are Ruth Putnam; Norah Walker; Grace Meston, who served as assistant manager of the editing department and operated the Bell and Howell printer; Ethel Ricketts, manager of the editing department; Al Heimerl, head of the camera and laboratory departments; Nancy McEwen; Margaret Graham; and Pansy Martin.

Automated film processors were not introduced until the 1920s. Early motion-picture labs used the rack-and-tank system, in which film was wound around spring-loaded wooden racks (to allow for shrinkage), which were then immersed in an open tank full of developer. After hypo and washing cycles, the film was wound onto drums such as this one for drying.

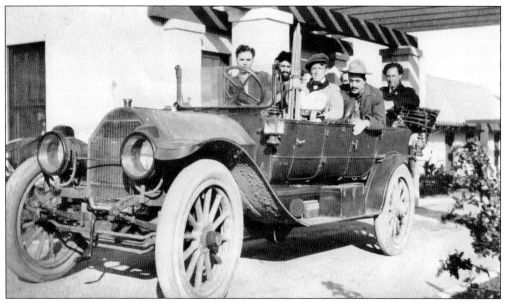

In the front seat are an unidentified driver and cameraman Roy Overbaugh, who is holding a Bell and Howell camera and a tripod in his lap. In back are Harry Von Meter (with beard), Jack Richardson (in campaign hat), William Garwood (partially obscured behind Richardson), and Sydney Ayres.

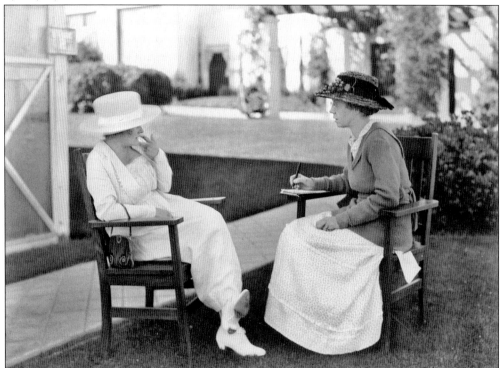

Flying A star May Allison (left) is interviewed by an unidentified fan-magazine reporter on the lawn in front of the small glass stage. Although it was built first, by 1916, when this photograph was taken, the sign on the corner of the stage visible behind May Allison designates it as "Stage 2."

Four

THE BLOWOUT AT SANTA BANANA

Santa Barbara was a sleepy community when the American Film Company settled there in 1912. The permanent residents were middle-class merchants, farmers, and working people, but the town and nearby Montecito were also destinations for well-to-do easterners who followed the sun to escape eastern snow.

The rich folks added prestige to the community, but prestige didn't pay the bills. Many local merchants complained that winter tourists often neglected to settle their accounts when they returned east. The new movie studio didn't offer much in the way of society. Studio workers were disruptive, loud, and without cultural refinement, but they did pay cash on the barrelhead for the goods and services required to produce their films.

For actors and other show folk, who were used to traveling around the country, working in tank town music halls, and living in seedy theatrical hotels, the movies offered the opportunity to plant roots. Wages for the studio workers were good for the period. Cameraman Roy Overbaugh earned $40 a week in 1913. Fellow cinematographer L. Guy Wilky recalled that he earned $60 a week at the Flying A in 1916. And salaries stretched further in those pre–World War I days. Actor-director Al Santell recalled, "In 1916 in Santa Barbara I had a wonderful room, my own private bath, two meals a day—and this whole thing cost me eighteen American dollars."

The downside for Santa Barbara old-timers, however, was that the picture people turned the streets into an extension of the studio. The common street corner scene wasn't the problem, but there were plenty of occasions when gunshots, chases, and cars racing across railroad tracks only inches in front of an approaching train seemed to bring more anxiety to the community than thrills to movie fans.

Much of the Santa Barbara community was documented in Flying A films. However, though the American Film Company produced nearly 1,000 films in Santa Barbara, only about 100 of the films are known to survive today, and much of the legacy of the studio exists only in still photographs.

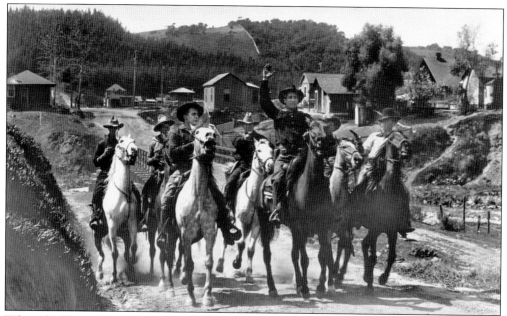

When the Flying A company arrived in Santa Barbara, much of the town and the surrounding communities still looked like the Old West. This scene from an unidentified 1913 film shows a posse led by Wallace Reid (front left) chasing down a bad man played by George Field (with raised hand).

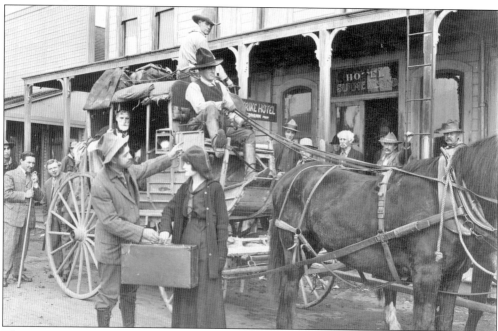

The town of Summerland, a few miles south of Santa Barbara, could easily double for a Western main street with its wooden sidewalks and false-fronted buildings. Here Jack Richardson points Vivian Rich to the Summerland Hotel. The stagecoach dated from 1849. It was the property of Emma Greenlee, a Santa Barbara movie fan who refused to sell it to the company but did allow them to use it in making pictures.

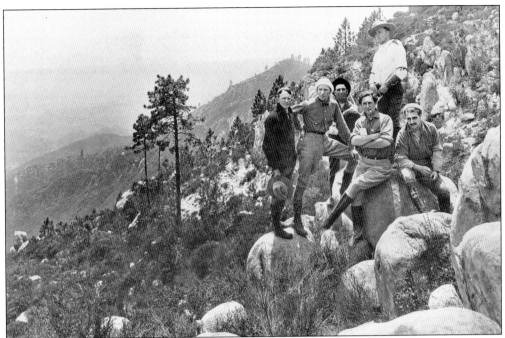

During production of *The Oath of Pierre* (released June 8, 1914) are, from left to right, cameraman Roy Overbaugh; assistant director B. Reeves Eason; unidentified; director Sydney Ayres; Pete Morrison (in white shirt); and William Garwood, who played the role of Pierre. Morrison (1890–1973) would go on to become a Western star at Universal in the 1920s. His brother, "Chick" Morrison (1878–1924) was the head wrangler at the Flying A.

Pierre "seeks consolation in the solitude of the forest heretofore untrod by man," reads a studio synopsis. William Garwood (1884–1950) came to the Flying A after working for the Selig Polyscope Company and Thanhouser Film Company. He worked in movies until 1919, both as an actor and director. A fondness for alcohol shortened his career.

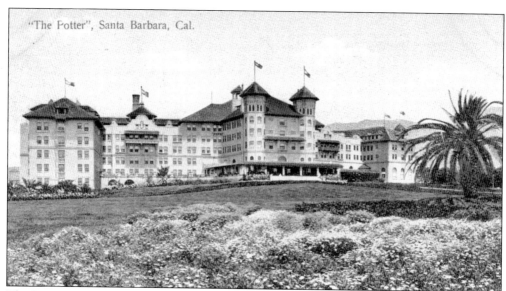

"The Potter", Santa Barbara, Cal.

The Potter Hotel, built by Milo Potter, opened in 1903 and had nearly 600 rooms as well as a zoo, a rose garden, its own farm for fresh produce, a ballroom, billiard rooms, a bowling alley, lounges, and gift shops. After Potter sold the hotel in 1919, it was renamed the Belvedere and in 1920 became the Ambassador. It burned to the ground on April 13, 1921.

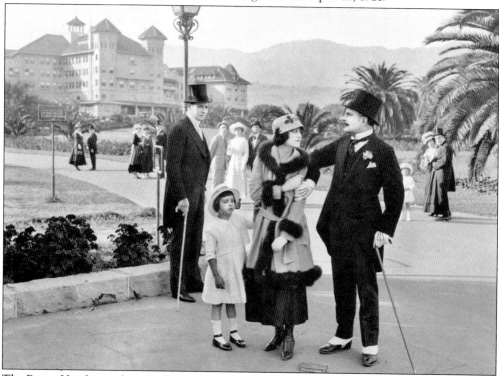

The Potter Hotel served as a backdrop for *Jealousy's First Wife* (released June 5, 1916), a two-reeler directed by Carl M. LeViness and featuring Alfred Vosburgh (by lamppost), Vivian Rich, and George Periolat as the jealous husband. Vosburgh changed his name to Gayne Whitman after the United States entered World War I to avoid any association with "the hated Hun."

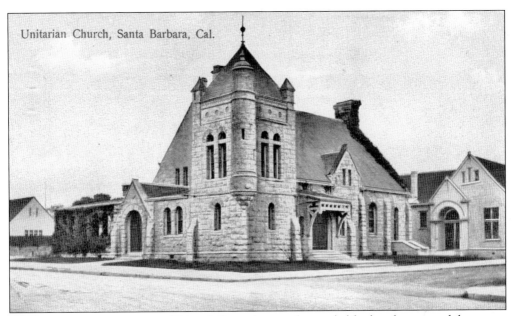

Unitarian Church, Santa Barbara, Cal.

For contemporary street scenes, Flying A filmmakers rarely traveled farther than around the corner to State Street. The Unitarian church on the northeast corner of State Street and Arlington Avenue served as the setting for this wedding scene, possibly from *The Day of Reckoning* (1915). Featured are Harry Von Meter (at left); Louise Lester (in dark dress) and Jack Richardson, who were husband and wife off screen; Jodie Eason and Peggy Perkins as bridesmaids; David Lythgoe and Vivian Rich as groom and bride; and Charlotte Burton (right). Lythgoe is a rather mysterious figure. His name disappeared from screen credits in 1915. Theater seems to have been his first love, and he appeared on stage well into the 1930s.

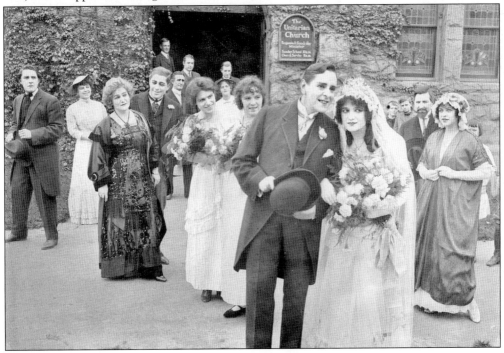

David Lythgoe is seen here on State Street, probably in *She Walketh Alone* (1915), directed by B. Reeves Eason. Across the street is the San Marcos Building, at the southeast corner of State and Anapamu Streets.

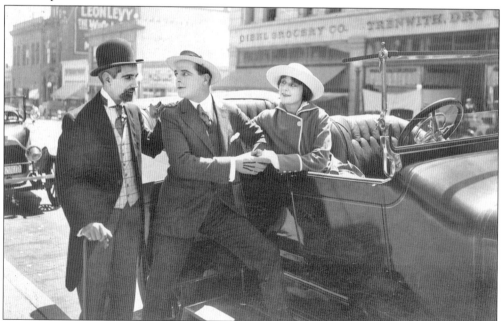

Another section of State Street is shown in 1915 in an unidentified film featuring Ed Coxen (in straw hat) and Lizette Thorne. Behind them are the Diehl Grocery Company at 827 State Street and Tenwith's Dry Goods at 829. Thorne retired from the screen in 1921 to raise a family. Coxen continued working in films into the early 1940s.

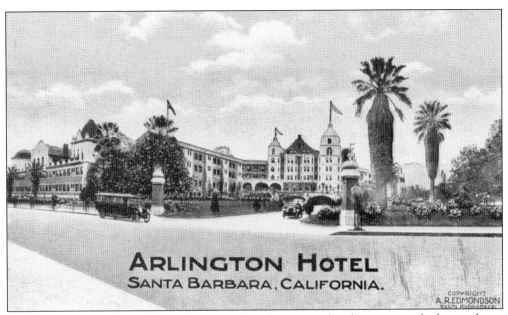

The Arlington, another of Santa Barbara's showplace resort hotels, was severely damaged in a 1925 earthquake and was not rebuilt.

Since most moviegoers were unfamiliar with Santa Barbara except as they saw it on screen, filmmakers saw no need to be literal in their use of buildings. In this unidentified 1915 film, the exterior of the Arlington substituted for a hospital. Vivian Rich is the nurse perusing the Santa Barbara *Daily News*. Rich (1893–1957) began her movie career with the Nestor Film Company in 1912 and joined the Flying A in 1913. She later signed with Fox Film Corporation and through the 1920s worked for a number of low-budget producers, finally retiring in 1931. She died in an automobile accident.

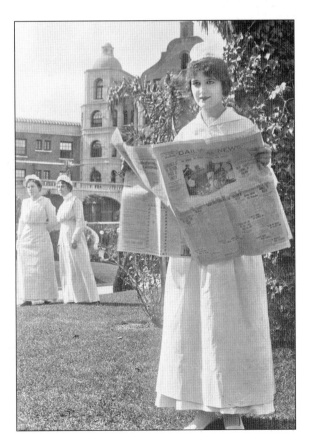

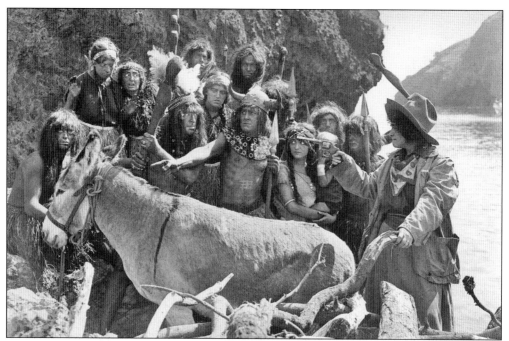

Santa Cruz Island off the coast of Santa Barbara was a favorite location for filmmakers. This is a scene from *Calamity Anne's Dream* (released November 22, 1913), directed by Lorimer Johnston. Louise Lester plays Calamity Anne. Among the natives are Carolyn Cooke (third from left), Harry Von Meter (pointing at the donkey), and Vivian Rich (to the right of Von Meter).

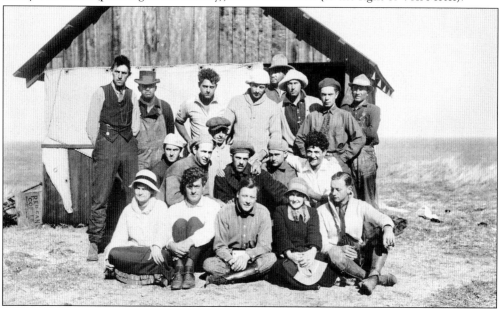

Lillo of the Sulu Seas (released February 8, 1916) was a three-reel, Clipper-brand drama produced at Pelican Bay on Santa Cruz Island. The film starred the popular screen team May Allison and Harold Lockwood. Pictured from left to right are (first row) May Allison's sister, William Stowell, Harold Lockwood, May Allison, and John Stalling; (second row) unidentified, assistant director Park Frame, Bob Solomon, director Jack Halloway, cameraman Robert Phelan, and Eddie Carillo.

Another popular location was Guadalupe sand dunes in northern Santa Barbara County, seen here in *The Buzzard's Shadow* (released December 9, 1915), a five-reel feature produced by the Flying A and released as a Mutual Masterpicture. Here the Indian Unitah (Harry Von Meter) tracks Sergeant Barnes (Harold Lockwood) across the burning sands.

In *The Buzzard's Shadow*, the Indian poisons the soldier's horse and substitutes sand for the water in his canteen. Driven mad by heat and thirst, Barnes treks the vast desert wastes and collapses across a railroad track. He is rescued but suffers amnesia. When he sees an American flag, however, it all comes back to him, and he goes on to capture Unitah.

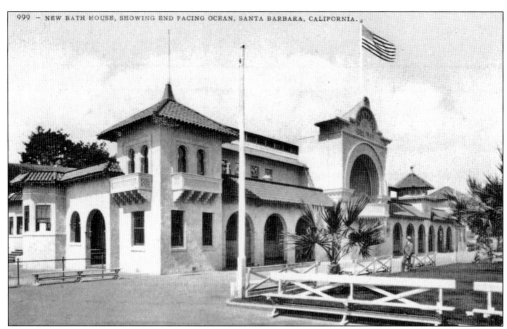

Los Banos Del Mar was the public bathhouse in Santa Barbara. Although the Pacific Ocean was one of Santa Barbara's attractions, swimming in the sea was not yet the popular pastime it would become. Bathers commonly took their dips indoors. The bathhouse served as a location for *Two Slips and a Miss*, an American Beauty brand comedy released July 12, 1916. Bathing beauties were a staple of silent comedies. In Hollywood, producer Mack Sennett was famous for his troupe of young woman clad in elaborate and somewhat ridiculous-looking bathing costumes, but the swimsuits these Santa Barbara girls wore were more down-to-earth and, surprisingly, more revealing than what the Sennett girls were wearing.

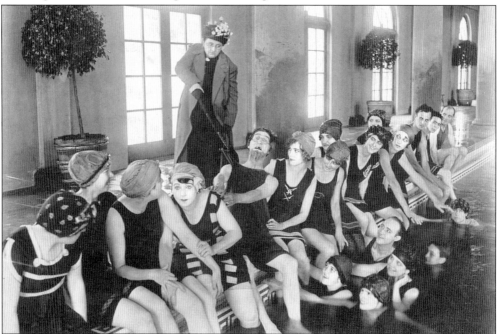

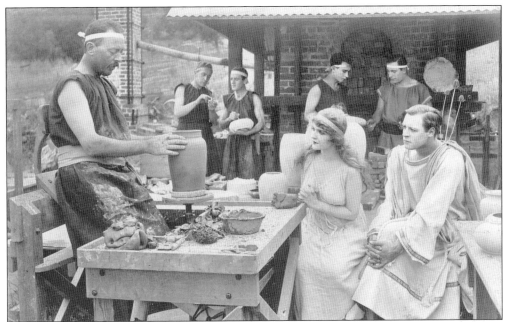

After hearing a lecture about ancient Greece, John Wright, played by Harold Lockwood (right), turns his estate into a modern Grecian colony in *The House of a Thousand Scandals* (released September 23, 1915), a four-reel Mutual Masterpicture. In this scene, Wright and his fiancée, Martha Hobbs, played by May Allison, watch famed art nouveau potter Frederick H. Rhead turn a vase. The Rhead Pottery Works was based in Santa Barbara from 1913 to 1917, and his work is highly prized today.

George Field and an unidentified actress play a scene across the street from La Petite Theatre, located at 622 State Street, a storefront temple of the arts that represented the very definition of small-time vaudeville.

In *Lola* (released September 7, 1914), the title character, played by Winifred Greenwood, returns home after an eight-year absence to find that her sister, played by Charlotte Burton (seated), has taken her place after her jilted boyfriend, played by Ed Coxen, called out for Lola when he was suddenly stricken blind. Director Cecil B. DeMille may have seen *Lola* and remembered it because his films *Something to Think About* (1920) and *Fool's Paradise* (1921) borrow plot elements from it.

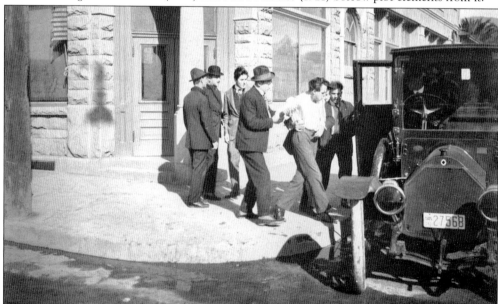

In 1915, Edward Coxen (in white shirt) made a series of mystery dramas in which he played a newspaper reporter with a nose for trouble. The title of this film is unknown, but the scene was shot in front of the Santa Cruz Island Wine Depot at the intersection of Anacapa and De La Guerra Streets.

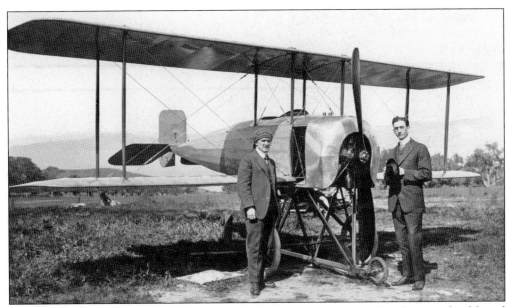

At Hope Ranch in 1914, Flying A cameraman Roy Overbaugh took this photograph of famed aviator Lincoln Beachey (left) and airplane manufacturer Glenn L. Martin, who were demonstrating Martin's new model TA tractor biplane. Lincoln Beachey would be killed doing air stunts at the Panama Pacific Exhibition in San Francisco less than a year later on March 14, 1915. Glenn Martin (1886–1955) went on to become one of America's top aircraft builders. His company later merged with Lockheed.

Ed Coxen and an unidentified actress step out of Harlow Frink's Premier roadster at the Potter Country Club in Hope Ranch in this unidentified 1915 film. Frink was the manager of the Great Wardrobe clothing store. The Premier Motor Manufacturing Company made cars in Indianapolis, Indiana, between 1903 and 1926.

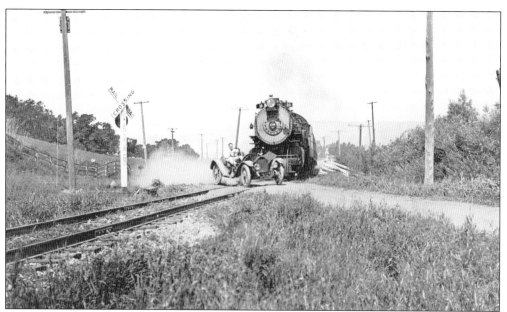

Stuntman Ted French spent a week timing this stunt for *The Diamond From the Sky* (1915). He raced the train, waved at the engineer, and put on the brakes every day until the day of the shoot. He got across, but just barely. The train clipped the car as it streaked past, and the engineer was so shaken he was taken off the train at Santa Barbara station. Ironically, the upright on the crossing sign reads, "LOOK OUT FOR THE CARS."

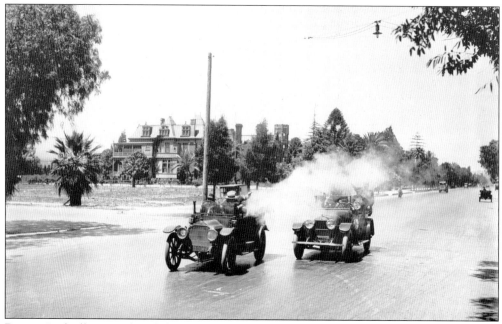

During "a thrilling revolver fight in . . . speeding autos, the bandits escape with the captured girl" in *The Secret Wire* (released January 14, 1916). Directed by Thomas Ricketts, photographed by Roy Overbaugh, and starring Harold Lockwood and May Allison, this two-reel drama kept audiences on edge and Santa Barbara residents in a panic as the streets seemed suddenly inhabited by gangsters.

Five

THIS HERO STUFF

Most of the actors in early films came from the lower ranks of the theatrical world. They were largely an assortment of stock company and touring actors who had played time-tested melodramas for working-class audiences at "popular prices" of 10, 20, or 30¢ a seat. Often they were players who could no longer find work on the stage as movies cut into the audience for the lower forms of live theater, or they were performers looking for a way to make ends meet when most legitimate theaters closed for the summer. Circus performers, vaudeville acrobats, and rodeo cowboys also saw the movies as a way to make a steady, if modest, living without having to "give up show business," as the man who hates cleaning up after the elephants refuses to do in the old joke.

Even though the movies provided a refuge for this ragtag group of troupers, the new medium was not always appreciated by those with aspirations for careers in the so-called "legitimate" theater. Margarita Fisher had been on stage since she was a child and appreciated the fact that the movies allowed her to stay put and set down roots, but she said her husband, actor-director Harry Pollard, was "strictly legit." Even though he was successful in motion pictures and became a top-flight director, he never had any real respect for the medium.

In 1915, Rube Miller, who later worked for Flying A head S. S. Hutchinson at the Vogue Film Company, wrote to a friend who was interested in trying her hand at the movies: "The picture game is not what it seems and I think it the worst branch of show business. The only thing that keeps me in it is the money and I had a bunch of luck favor me when I started as I got in with the Keystone [Film Company] and started the rough stuff and the police force [the Keystone Kops] which made such a big hit and made a name for myself and now I make much more than I could on the road."

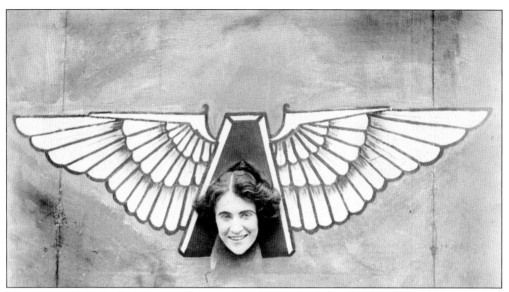

Many stage players looked down on the movies and were afraid that they would hurt their standing in legitimate theater by working in "galloping tintypes," and producers feared that publicizing performers would cause them to want more money. This thinking began to change in 1909, when the Selig Polyscope Company advertised that stage favorite Hobart Bosworth appeared in *The Roman*, but the practice of keeping actors anonymous was maintained by many producers until late 1911. The American Film Manufacturing Company was an exception. They promoted matinee idol J. Warren Kerrigan from the beginning and also leading lady Pauline Bush, as the above photograph demonstrates.

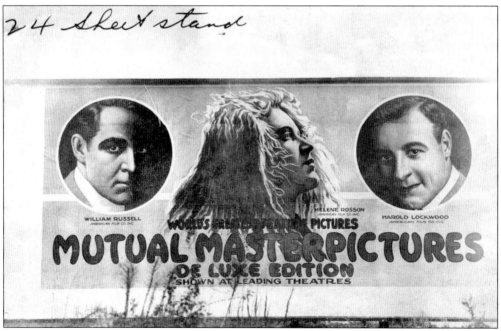

A snapshot of a 24-sheet billboard from 1916 promotes the Mutual Masterpictures feature line and American Mutual stars William Russell, Helene Rosson, and Harold Lockwood.

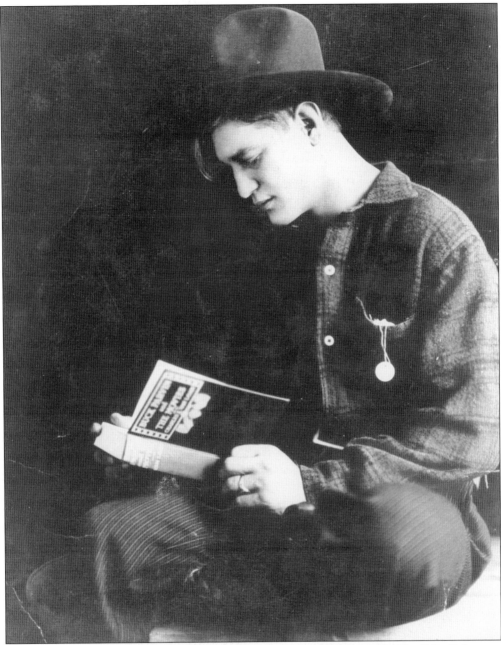

One of the more interesting Flying A stars was Art Acord (1890–1931). The Selig Polyscope Company hired Acord in 1909, when he was appearing with the Dick Stanley Wild West Show in Los Angeles, and he served as the inspiration for the character Buck Parvin, who was featured in a series of short stories about movie making by Charles E. Van Loan that appeared in *The Saturday Evening Post* and *Cosmopolitan* magazine between 1914 and 1916. Several of Van Loan's stories were collected in the book *Buck Parvin and the Movies*. The Flying A acquired the rights to Van Loan's book and hired Acord to portray the fictional screen cowboy he had inspired. Here Acord peruses the book that would serve as the basis for the films that elevated him to stardom.

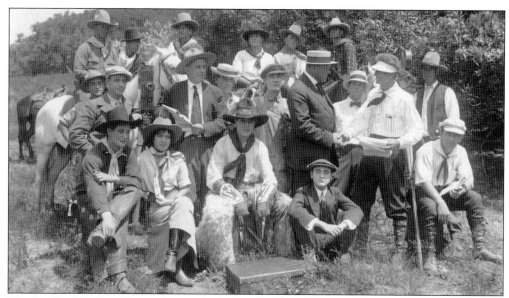

The first Buck Parvin film was *Man-Afraid-of-His-Wardrobe* (released October 2, 1915). Van Loan's stories were based on the experiences of directors Francis Boggs and Hobart Bosworth making films at Selig. Larry Peyton (holding script, left center) played the fictional director Jimmie Montague, and E. Forrest Stanley (on horse next to Peyton) was featured as stage star A. Lester Hale (said to be inspired by Sydney Ayres), who played Western heroes on stage but who could not ride a horse in real life. Anna Little (third from left) played Myrtle Manners (inspired by Selig screen star Kathlyn Williams). Art Acord (fifth from left) played Buck Parvin.

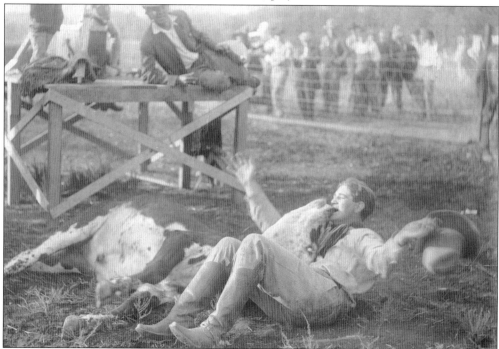

Art Acord bulldogs a steer for the Flying A cameras, following the long-since-abandoned custom of biting the lip of the downed animal.

Film Tempo (released December 4, 1915) featured George Webb (left) as low-life stage actor Norman Dean, who makes a bust in the movies but wins the heart of small-town girl Charlotte Biggs, played by Nell Franzen. Dean borrows money from members of the picture company and persuades Charlotte to elope with him, forgetting to mention he is already married. Buck Parvin, played by Art Acord (right), arrives at the station just in time to thwart Dean's plan and rescue Charlotte from a fate worse than death. The Buck Parvin films were photographed by L. Guy Wilky, who would become a founding member of the American Society of Cinematographers in 1919. Because of slow film stocks, "night for night" photography was relatively unusual, and here Wilky makes excellent use of augmented light coming from inside the train station.

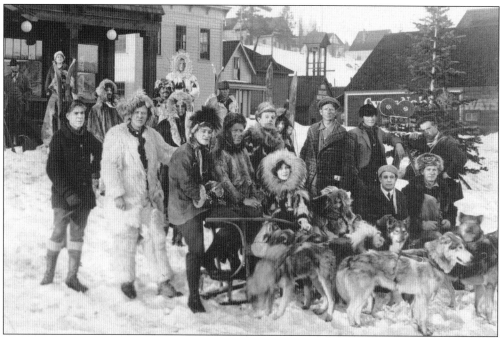

For *Snow Stuff* (released March 24, 1916), the Mustang unit went on location to Truckee, California. Among the group were William Jennings (left), Larry Peyton (second from left), Art Acord (third from left), leading lady Dixie Stratton (center), leading man Ashton Dearholt (behind Stratton), director William Bertram (standing right of Stratton), and cameraman L. Guy Wilky (standing right of Bertram).

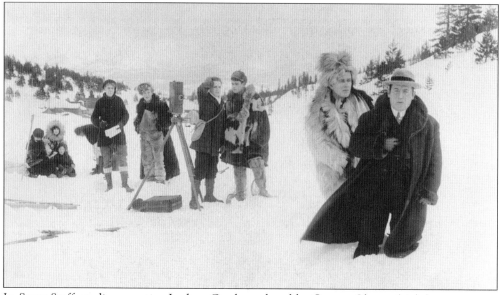

In *Snow Stuff*, studio executive Isadore Gordon, played by George Clancy (right), attempts to seduce the leading lady while he shows the company how he'd make the movie if he were directing. Dixie Stratton is seated in the background, William Jennings holds the script, and Hardy Gibson (hand to head) is playing cameraman Charlie Dupree. Ashton Dearholt stands next to Gibson, and Larry Peyton comforts the executive, who has been hit on the head by the leading lady.

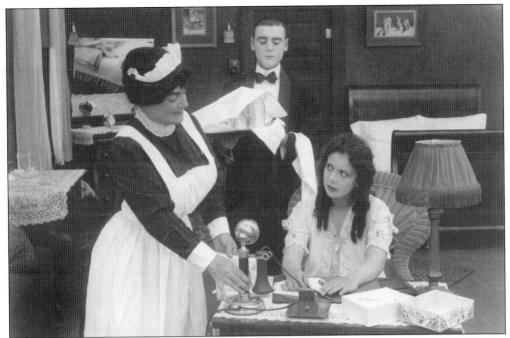

With the successes of *The Adventures of Kathlyn* (Selig, 1913), *The Perils of Pauline* (Eclectic-Pathé, 1914), and *Lucille Love, The Girl of Mystery* (Universal, 1914), serials became hot box-office attractions. The Flying A got on the serial bandwagon in 1915 with *The Diamond From the Sky*, which was planned as a 15-episode thriller. The Flying A hoped to sign "America's Sweetheart," Mary Pickford, to star, but they settled for her sister Lottie Pickford (1895–1936). Here a maid offers the phone to Esther Blair, played by Lottie.

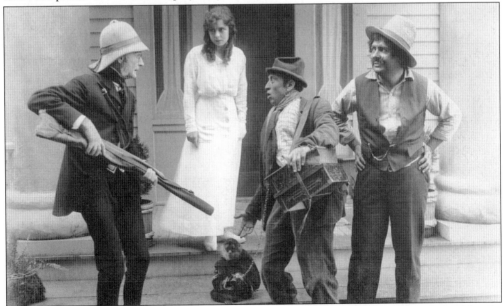

From left to right (foreground), Marmaduke Smythe (played by Oral Humphrey), Quabba the Hunchback (William Tedmarsh), and Luke Lovell (George Periolat) prepare for adventure with Esther Blair (Lottie Pickford) in *The Diamond From the Sky.*

Margarita Fischer (1886–1975) was already a veteran performer with 20 years' stage experience when she joined the Flying A in 1914 to star in Beauty brand comedies. She was married to actor-director Harry Pollard, and although he would go on to a successful career as a filmmaker, Fischer remembered that Pollard was "strictly legit" and never reconciled with the fact that he worked in the "flickers." In 1915, Fischer and Pollard were set up in an affiliated company, Pollard Picture Plays, to produce feature films for Mutual. She returned to the Flying A in 1917 and remained there until it closed. During World War I, Fischer dropped the "c" from her name to disavow her German ancestry.

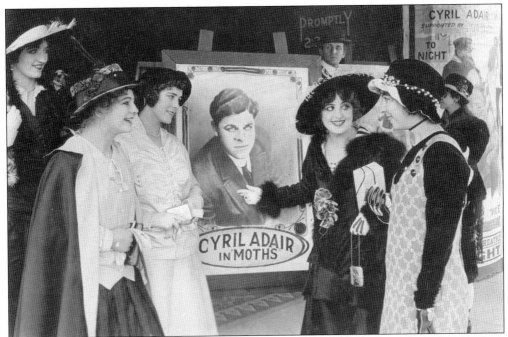

At four reels, *Infatuation* (released September 2, 1915) was too long to be considered a short and too brief to really be a feature. The film starred Margarita Fischer as a girl who leaves her widowed father to marry matinee idol Cyril Adair, played by Harry Pollard (pictured on the poster). Seen from left to right are unidentified, Ann Forrest, Jimsy Maye Eason, Margarita Fischer, and Peggy Perkins.

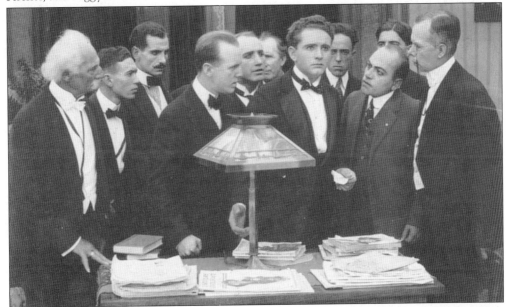

Like Margarita Fischer, Frank Borzage came to the Flying A to star in Beauty brand comedies. In this unidentified 1915 film, Borzage (staring off-screen right) is supported by William Frawley (to the left of Borzage), who is best remembered as the Ricardos' landlord, Fred Mertz, in the long-running 1950s television series *I Love Lucy*.

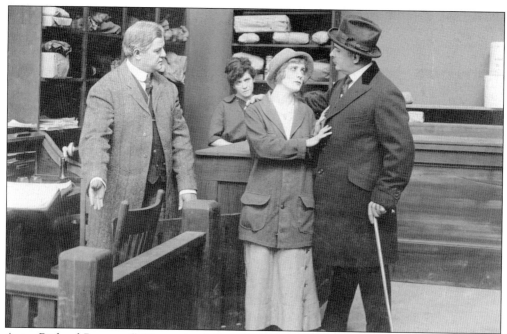

Actor Richard Bennett (left) was the father of two movie stars, daughters Joan and Constance Bennett, but his own film work was sporadic, and he was primarily known for his stage work. His movie career started with a bang, however, when he appeared in a film adaptation of *Damaged Goods* (first released September 15, 1914), which dealt with the forbidden topics of sexual promiscuity and syphilis. Originally directed by Thomas Ricketts and released in five reels, *Damaged Goods* was reissued in 1917 with additional scenes directed by Bennett to stretch the material to seven reels. Jimsy Maye Eason and George Periolat are the other principals in this scene.

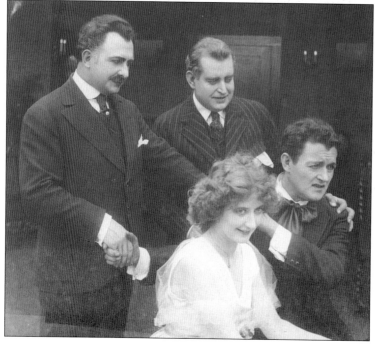

Over two years, Richard Bennett starred in six features for Flying A, including *Phillip Holden, Waster* (released October 9, 1916). In this scene are, from left to right, George Periolat, Clarence Burton, Rhea Mitchell, and Richard Bennett.

William Russell (1884–1929) was one of the Flying A's top stars from 1916 to 1919. He came to Santa Barbara in 1915 to appear as the villainous Blair Stanley in *The Diamond From the Sky*. Director Henry King, who worked with Russell, recalled that he was likeable and athletic. "He wanted to be Douglas Fairbanks," King added. While in Santa Barbara, Russell married fellow Flying A player Charlotte Burton. They divorced in 1921. Among his better Flying A films were *A Sporting Chance* and *Six Feet Four* (both 1919). After leaving Santa Barbara, he signed with the Fox Film Corporation, but his most enduring film is the 1923 adaptation of Eugene O'Neill's *Anna Christie* (1923), produced by Thomas H. Ince.

Douglas Fairbanks (left) visits William Russell in Santa Barbara while on location for his 1916 film *American Aristocracy*. Lloyd Ingraham, the director of *American Aristocracy*, is third from left, and the fellow with the cauliflower ears is wrestler-actor Bull Montana.

William Russell wanted to emulate the athletic stunts performed by Doug Fairbanks, and he certainly had the chance to do so performing this stunt for *The Frame Up* (released May 7, 1917). Harvey Clark drives the open roadster as Russell makes the car-to-car transfer. Francelia Billington is the girl in the front seat of the taxi, and director Edward Sloman stands hunched over the camera on the camera car.

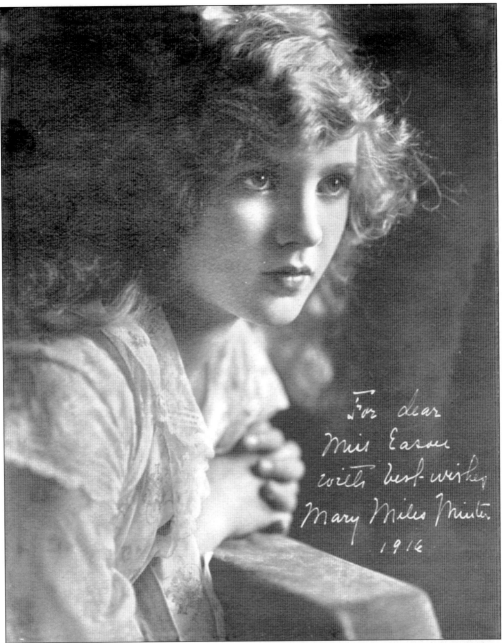

For dear
Miss Eason
with best wishes
Mary Miles Minter
1916

Mary Miles Minter (1902–1984) came to resent the control of her domineering stage mother. Born as Juliet Shelby, she assumed the name of a deceased older cousin to thwart the efforts of the Gerry Society to keep young children from working on stage. Her biggest theatrical success was *The Littlest Rebel* (1911), in which she appeared on Broadway and on the road. Minter entered films in 1915 and joined the Flying A in 1916. She remained at the studio until 1919, when she signed with Realart, a Paramount subsidiary. Those who knew her in Santa Barbara remembered her as a headstrong girl who sought the father she never knew in her directors. An affair with actor-director James Kirkwood led to pregnancy and an abortion, and her mother, Charlotte Shelby, was known to scour Santa Barbara, pistol in hand, trying to end their trysts.

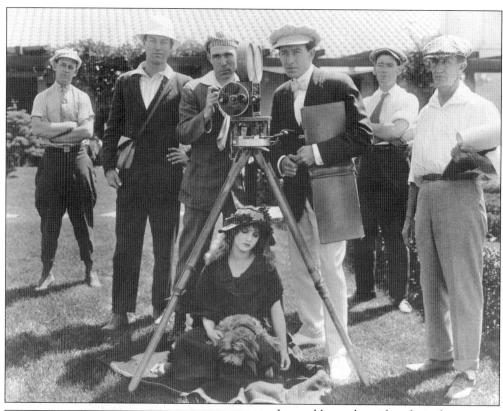

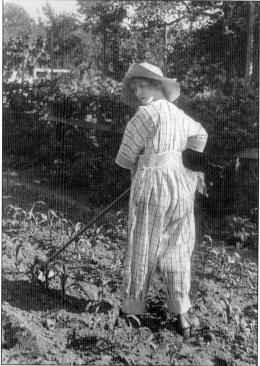

In a publicity shot taken from the production of *Youth's Endearing Charm* (released September 4, 1916), Mary Miles Minter's first film for the American Film Company, the star naps beneath the camera as cinematographer Faxon Dean turns the crank. Director William C. Dowlan is to the right of the camera. Sidney Algier is second from right. The studio building for directors and writers is in the background.

When Mary Miles Minter was shown this publicity photograph from *Youth's Endearing Charm* in later years, she snorted, "I never worked in a garden in my life. I always hired gardeners." But 1916 audiences believed the wholesome images the studio publicity department fed to the fan magazines. In real life, Minter was demanding and manipulative and insisted on having her own way.

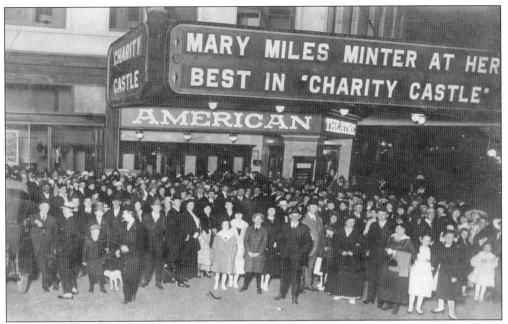

A crowd outside the American Theatre, at 1709 San Pablo Avenue in Oakland, California, is shown waiting to see *Charity Castle* (released September 13, 1917), the latest Mary Miles Minter film from the Flying A studio in Santa Barbara.

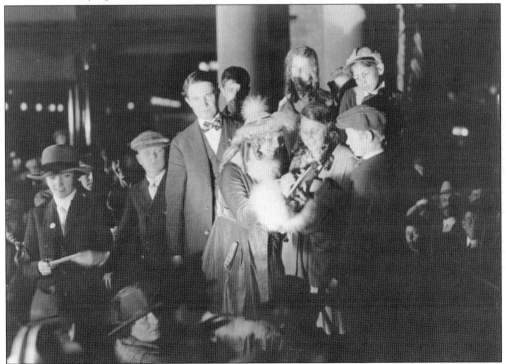

Mary Miles Minter is surrounded by autograph seekers at a Santa Barbara Liberty Loan rally on April 19, 1918. Enthusiasm for the seemingly endless stream of war-bond issues was waning before movie and stage stars were enlisted to help sell them to the public.

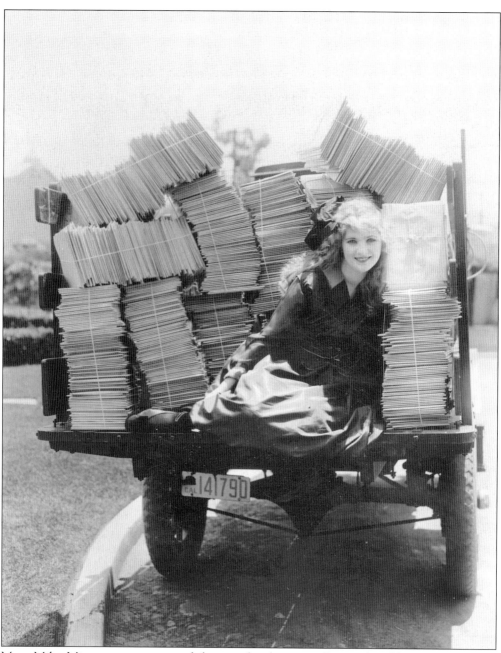

Mary Miles Minter poses on a truck leaving for the post office with publicity photographs requested by fans. Often such publicity photographs were autographed but rarely by the star herself. Secretaries, or sometimes Mary's mother, would supply the bogus signatures. The volume of photographs shown here may be another example of "gilding the lily" by the studio publicity department, but Minter was extremely popular with fans. Her innocent screen image was shattered in 1922, when her former director, William Desmond Taylor, was murdered in Los Angeles, and it was revealed that she had written love letters to him. But she continued making pictures and only retired from the screen in 1923 at the age of 21, when she was no longer bound by her mother's signature on her 1918 five-year Realart contract.

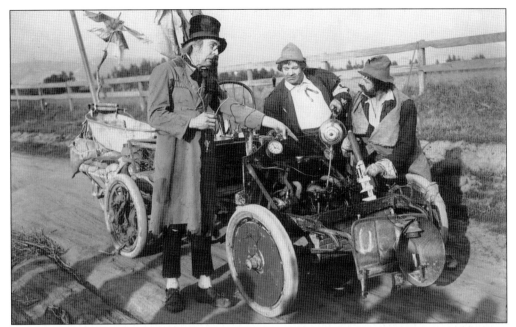

The comedy team of C. William Kolb (1874–1964) and Max M. Dill (1876–1949) were well-known on stage for starring in their own musical comedy shows—the West Coast equivalent of famed New York "Dutch" comics Weber and Fields. In the 1930s, C. William Kolb, billed as Clarence Kolb, became an often-seen character actor in Hollywood and is best remembered for playing such grouchy characters as Mr. Honeywell on the 1950s television series *My Little Margie*. Pictured from left to right are Kolb, Dill, and Harvey Clark in *Lonesome Town* (released December 11, 1916). Note the shadows of the camera crew in the foreground.

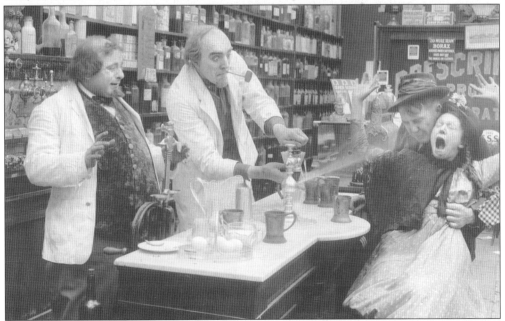

The team of Kolb and Dill act in *A Million for Mary* (released August 21, 1916), the first of their seven films for the American Film Company.

Harold Lockwood (1887–1918) was a film veteran, on screen since 1911, and May Allison (1890–1989) was a newcomer with only a couple of credits when they teamed up at Flying A in the four-reel feature *The Secretary of Frivolous Affairs* (released July 8, 1915). Here a romantic moment is shared by the duo in *The Broken Cross* (released February 1, 1916).

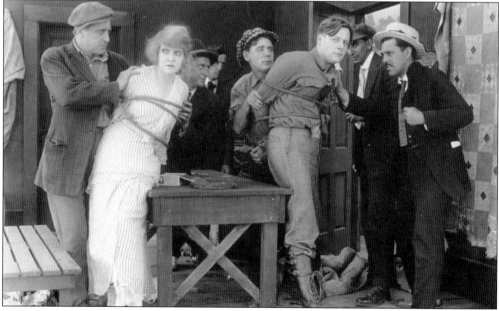

After their initial splash, however, Lockwood and Allison primarily starred in two-reelers. Few dramatic stars of their box-office stature were still appearing in shorts in 1916, and they were soon lured away by Metro Pictures, where they remained popular until Lockwood's death from Spanish flu. May Allison retired from films after her 1926 marriage. Here they are bound and gagged in *The Secret Wire* (released January 14, 1916).

Six

MUTUAL MOVIES MAKE TIME FLY

After much conflict among independent producers about how their pictures would be distributed, two rivals emerged. The Universal Film Manufacturing Company pooled the stock of its individual producers to create a new single company headed by Carl Laemmle of the Independent Moving Pictures Company (IMP). The Mutual Film Corporation followed a different model. It was a cooperative venture in which each of the participating producers retained independence.

The American Film Manufacturing Company affiliated with Mutual, as did the Thanhouser Film Corporation, the U.S. branch of the French Gaumont Company, David Horsley Productions, Reliance-Majestic, and the New York Motion Picture Corporation with its popular Keystone and Broncho film brands.

Under the leadership of Harry Aitken, who headed Reliance-Majestic, and promoting their offerings with the slogan "Mutual Movies Make Time Fly," the releasing organization provided exhibitors with a potent lineup of product. However, as feature films gained public favor, production costs began to soar, and profits became less predictable. Disputes arose within Mutual. Flying A, Thanhouser, Horsley, and Gaumont accused Aitken of favoring the productions of the New York Motion Picture Corporation and his own Reliance-Majestic features over those of the other member companies.

In 1915, these concerned producers engineered a coup, forcing out Harry Aitken and installing John R. Freuler, who was affiliated with both the American and Thanhouser companies, as the new president of Mutual. The new arrangement proved more equitable for the Flying A, but it was a victory gained at great cost.

Adam Kessel and Charles O. Baumann of the New York Motion Picture Corporation withdrew from Mutual to join Aitken in a new venture, the Triangle Film Corporation, and in one stroke, some of the most valuable contributors to the Mutual program were lost to the new concern, including directors D. W. Griffith, Mack Sennett, and Thomas H. Ince, and such stars as William S. Hart, Lillian Gish, and Charles Ray.

Ultimately the split would prove disastrous to both Mutual and Triangle, but initially the new arrangement strengthened the position of the American Film Company, and the Santa Barbara studio entered its most active production phase.

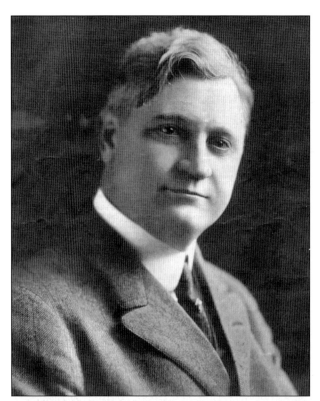

John R. Freuler (1872–1958) was the silent partner of S. S. Hutchinson in the American Film Company and became president of the Mutual Film Corporation in 1915. Freuler inherited a highly successful distribution company, but in less than three years, Mutual was bankrupt. Freuler's granddaughter, Jessie Walker, remembered him as "a natural gentleman. He was polite and formal without effort. He never came to the table without a suit coat, white shirt, and tie. His weakness lay in his poor judgment of character. His wife helped him judge people and situations. She died of a heart attack while he was president of Mutual."

This winged clock with animated hour and minute hands appeared at the end of the Flying A films released through Mutual.

P. G. Lynch sits with his daughter. Lynch was in charge of day-to-day operations at the Flying A studio. He was a devout Christian Scientist, and a number of studio workers joined the church because it was deemed politically wise to do so. Lynch's promotion of Christian Science caused deep and lasting divisions among Flying A personnel, and non–Christian Scientists at the studio were so upset at Lynch's refusal to seek medical advice when his daughter was gravely ill that they continued to denounce Lynch more than 50 years later.

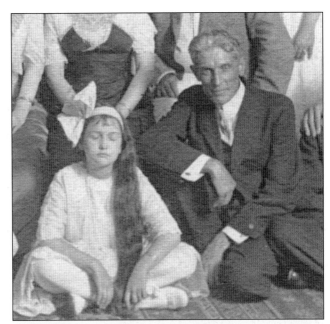

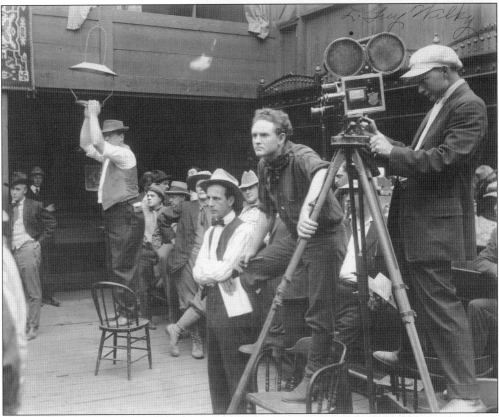

Among the Christian Science converts were cinematographer L. Guy Wilky (right) and assistant director Park Frame (arms folded, holding script), seen here with director Frank Borzage during production of *Land o' Lizards* (released September 21, 1916).

Alois G. Heimerl headed the Flying A camera department from 1913 until the studio closed in 1921. He began his career in 1912 with the St. Louis Motion Picture Company, which, despite its name, was based in California. Heimerl operated a camera early on but primarily supervised other cinematographers and ran the studio laboratory and editing department.

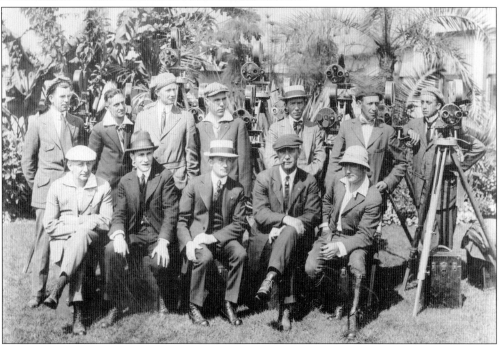

The Flying A camera staff in 1916 are, from left to right, (seated) Harry Fowler, John Seitz, Alois G. Heimerl, Karl Weiden, and Robert Phelan; (standing) Ira Morgan, Len Smith, L. Guy Wilky, Faxon Dean, Tom Middleton, Harry Hawkins, and George Scott.

Cinematographer Harry M. Fowler (1884–1954) came to the Flying A in 1916, and his first assignment was on *A Million for Mary*, starring Kolb and Dill. Like his boss, Al Heimerl, Fowler started his career at the St. Louis Motion Picture Company.

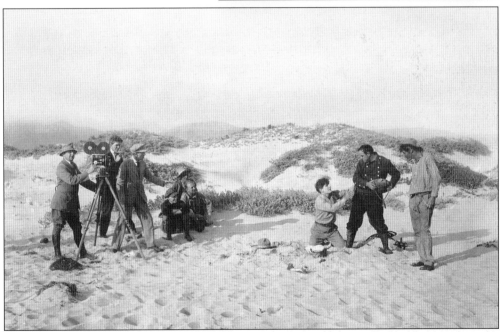

The American Film Company often went on location to Guadalupe sand dunes in northern Santa Barbara County. This photograph was taken during production of *The Blindness* (released May 19, 1916). Harry Fowler was the cinematographer, and Carl LeViness (with raised arm) was the director. In the cast were William Stowell (kneeling) and Roy Stewart (holding canteen).

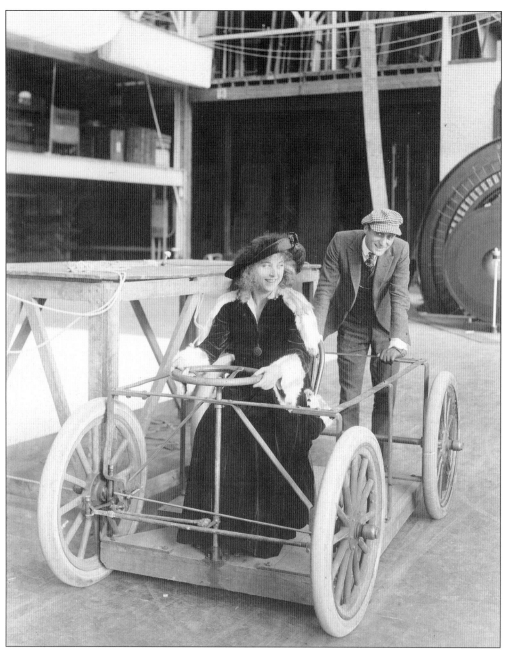

Director Edward Sloman pushes Francelia Billington around the big glass stage on a camera perambulator. Sloman (1886–1972) was born in London and began his career as an actor in Britain. He came to the United States about 1910 and worked as a screen actor before becoming a director. Billington (1895–1934) started making pictures for the Kalem Company in 1912. She was never a star but was known as a leading lady at a time when such distinctions were considered important. Her biggest break came in 1918 when she appeared in Erich von Stroheim's *Blind Husbands* (Universal, 1918), but her career faltered when she chose to appear opposite her husband, Lester Cuneo, in a series of low-budget Westerns in the early 1920s. Cuneo committed suicide in 1925, and Billington died of tuberculosis at age 39.

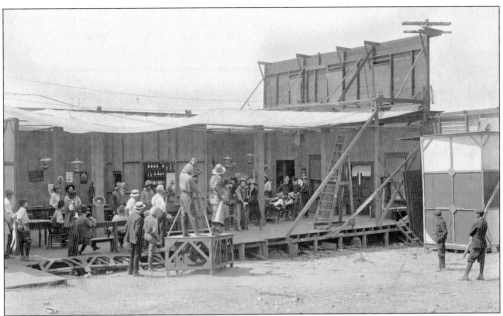

An elaborate saloon set for a 1916 Mustang brand two-reeler was photographed by L. Guy Wilky under the direction of Frank Borzage.

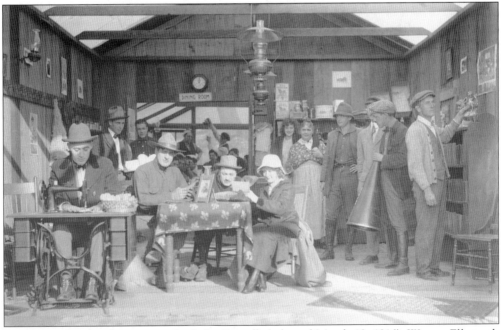

Another indoor/outdoor set was built for *Overalls* (released March 18, 1916). Warren Ellsworth sits at the sewing machine. William Stowell and Rhea Mitchell sit at either side of the center table. Director Jack Halloway holds the megaphone, and cinematographer Robert Phelan (wearing open-neck shirt) stands with hand on hip. Although electric lights were used in filmmaking as early as the 1890s, it was more common, especially in sun-drenched California, for filmmakers to shoot even interior scenes in natural light. L. Guy Wilky said, "You could pr't near duplicate any kind of lighting using diffusers, reflectors, and mirrors."

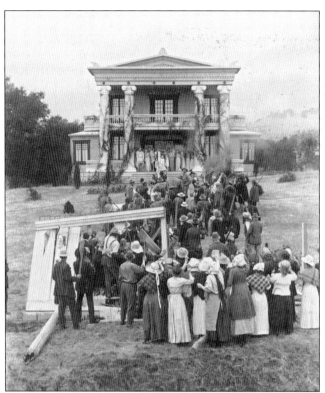

The Flying A took a distinctly "artistic" turn in 1915 and 1916, making several films intended to tweak the nose of censors while remaining within the bounds of refinement if not respectability. *The House of a Thousand Scandals* (released September 23, 1915) told the story of John Wright (played by Harold Lockwood), a wealthy young man who befriends Martha Hobbs (played by May Allison), a worthy but poverty-stricken lass. Enthralled by a lecture on ancient Greece, he decides to establish a modern Greek colony on his estate. Martha's grandfather and her would-be suitor fear her morals are being compromised and lead a mob to attack the utopian community. Here the mob gathers.

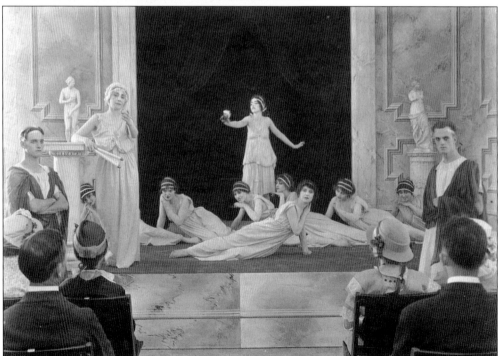

Josephine Ditt, the wife of director Thomas Ricketts, delivers a lecture on life in ancient Greece in *The House of a Thousand Scandals.*

The House of a Thousand Scandals was controversial for a number of reasons. The Selig Polyscope Company sued the Flying A, claiming that the title of the film was designed to confuse audiences into believing they were going to see *The House of a Thousand Candles* (also 1915), based on a novel by Meredith M. Nicholson, which Selig had brought to the screen. Censor boards were concerned that at least one scandal was evident in the film because the unclad female form was in evidence. Here Martha's suitor dynamites John Wright's estate.

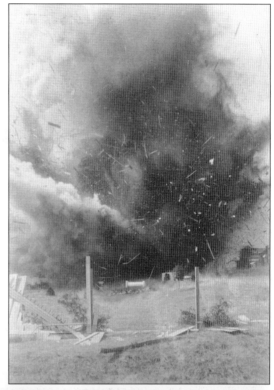

Among the sensations inspired by ancient Greece in *The House of a Thousand Scandals* was this display of "living statues." Director Thomas Ricketts persuaded local Santa Barbara girl Alice Anaroni (second from right) to bare her breasts for the film, and she obliged, only to later regret it when the boys around town made fun of her.

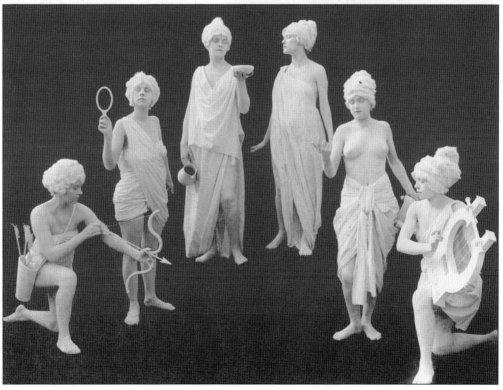

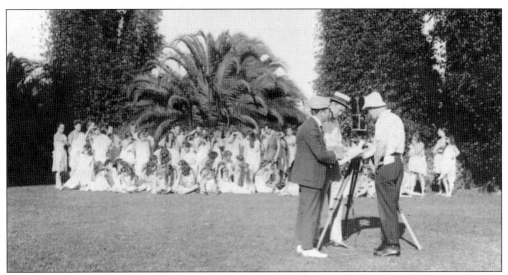

A bigger sensation was *Purity* (released July 13, 1916). Director C. Rea Berger (wearing white shoes) goes over the script with cinematographer Robert Phelan (right) as they prepare to shoot one of the symbolic scenes that helped justify the nudity.

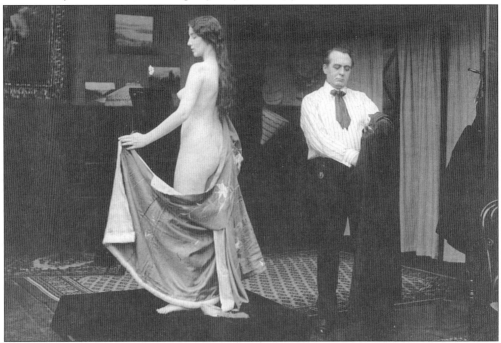

Purity (Audrey Munson) disrobes for artist Claude Lamarque (played by Alfred Hollingsworth). Screenwriter Clifford Howard later wrote in *Close Up*, "Munson . . . leaped into fame as a result of having been chosen out of a multitude of models to pose for the figure of the memorial coin of the World's Fair in 1915. At the height of her popularity the president of the American Film Co. secured a contract with Munson to appear in a motion picture. . . . I hit upon the title *Purity* . . . and constructed the scenario . . . along highly poetic and idealistic lines. . . . Whatever may be said of the outcome as a production of art, it fulfilled the company's expectations as a profitable sensation."

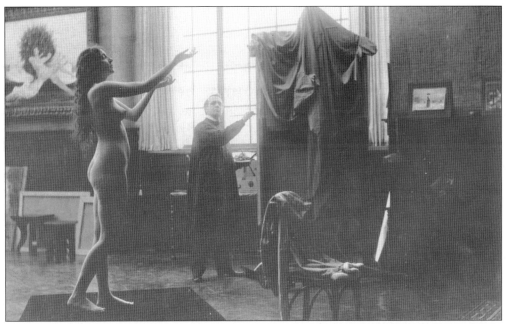

Purity was a moralistic tale about a starving poet who cannot find a publisher for his work. His girlfriend, Purity, becomes a model to raise money so he can self-publish, but when he learns that she has posed in the nude, he swears he will have nothing more to do with her.

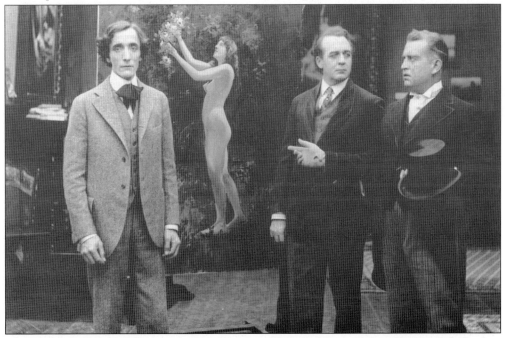

The moment of realization occurs when the poet, Thornton Darcy (played by Nigel de Brulier, left), first sees the painting and comes to realize the model's innocence has not been compromised because her motive for posing was entirely wholesome. Also in the scene are Alfred Hollingsworth (center) and Clarence Burton. In 1931, Munson was institutionalized and spent the last 65 years of her life in a mental sanitarium.

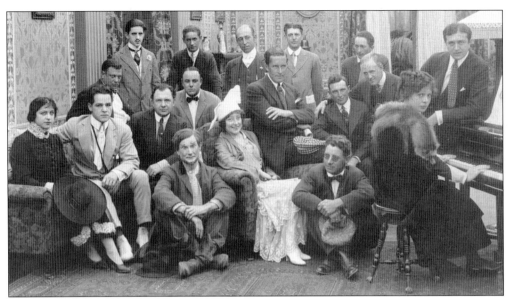

The Diamond From the Sky (1915) was originally intended as a 15-episode chapter play but proved so popular that it was expanded to 30 episodes during production. William Desmond Taylor directed the first 10 episodes, and Jacques Jaccard took over when Taylor was lured away by Hollywood. Depicted is the original *Diamond From the Sky* company. From left to right are (first row) Charlotte Burton, William Russell, George Periolat, Roy Stewart, Eugenie Forde, William Desmond Taylor, Lottie Pickford, and Irving Cummings. William Tedmarsh stands behind and to the left of Taylor. William Desmond Taylor would become the victim of a famous unsolved movie-land murder in 1922.

In contrast to its predecessor, *The Sequel to the Diamond From the Sky* wove its story in only four chapters. This group includes assistant director Sidney Algier (left), William Russell (second from left), Oral Humphrey, Charlotte Burton, cinematographer Ira Morgan, Rhea Mitchell (fifth from right), William Tedmarsh (third from right), and director Edward Sloman (right).

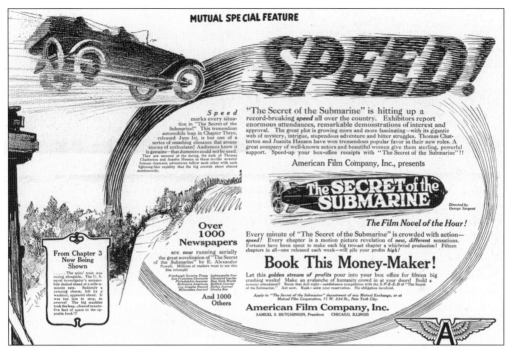

The Flying A serial for the 1916 season was *The Secret of the Submarine*, which was replete with the requisite number of thrilling incidents designed to keep audiences coming back week after week. This trade advertisement for episode three features an automobile leaping across a yawning chasm.

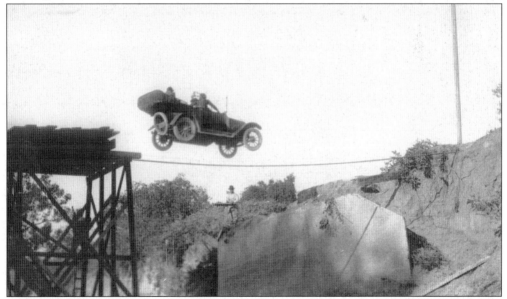

The artist clearly referenced this still taken of the scene even to drawing in a portion of the raised ramp that helped give the car the proper trajectory. Ted French, who drove the car for this scene, recalled that he made it across but that the wheels folded up like an accordion when he hit the ground on the other side, and the car stopped dead in its tracks. The passengers, of course, were dummies.

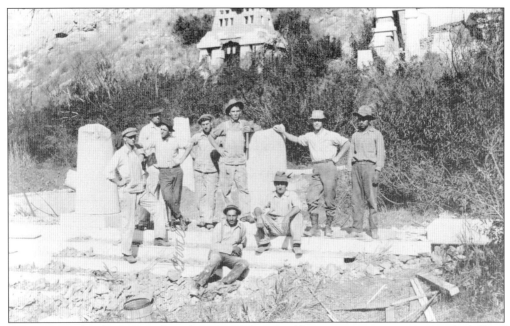

A crew from the Flying A studio takes a break from building ancient Mayan ruins in the hills of Oxnard for *In Bad* (released January 14, 1918). Such solid, three-dimensional sets were a far cry from the painted flats that had served the company only a few years before.

A closer view of the Mayan temple shows the care and detail that went into its construction. Seated on the steps are Clarence Burton and Francelia Billington. Burton (1882–1933) was on stage from age five and entered films in 1912. He was in Santa Barbara from 1916 to 1919 and then became a busy character actor in Hollywood. Burton was a particular favorite of director Cecil B. DeMille, appearing in all of DeMille's films from *Male and Female* in 1919 through *The Sign of the Cross* in 1932.

SUNDAY		MONDAY		TUESDAY		WEDNESDAY		THURSDAY		FRIDAY		SATURDAY	
1 Da.	½ Da.	1 Da.	½ Da.	1 Da.	½ Da.	1 Da.	½ Da.	1 Da.	½ Da.	1 Da.	½ Da.	1 Da.	½ Da.

Week Ending⋯⋯⋯⋯⋯⋯⋯⋯⋯191⋯⋯

AMERICAN FILM COMPANY, Inc.

WORK CARD

Rate⋯⋯⋯⋯⋯⋯⋯

Time⋯⋯⋯⋯⋯⋯⋯

Name⋯⋯⋯⋯⋯⋯⋯⋯⋯⋯⋯⋯⋯⋯⋯⋯⋯⋯⋯ Amount⋯⋯⋯⋯⋯⋯

Dept.⋯⋯⋯⋯⋯⋯⋯⋯⋯⋯⋯⋯⋯ By⋯⋯⋯⋯⋯⋯⋯⋯⋯⋯⋯⋯

Day workers, not under contract or on weekly salary, filled out time cards, such as this one. No provision seems to have been made for assigning one's labor to a specific film or production number, indicating that all such labor would have been apportioned to individual films by the accounting office or carried as general overhead.

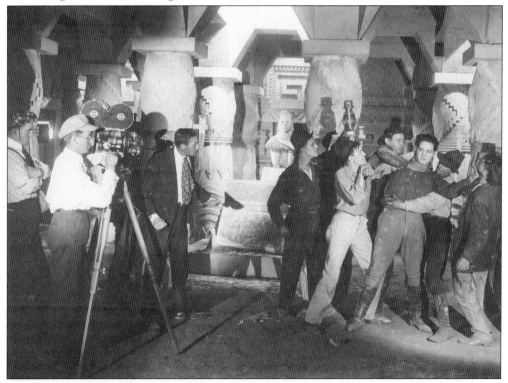

The climactic fight from *In Bad* has Bill Russell fending off an attack by five of the villain's henchmen. *In Bad* was one of the last Flying A pictures released by Mutual before the distributor closed down. It was dusted off, given a new title, and re-released as *Quick Action* on January 1, 1921.

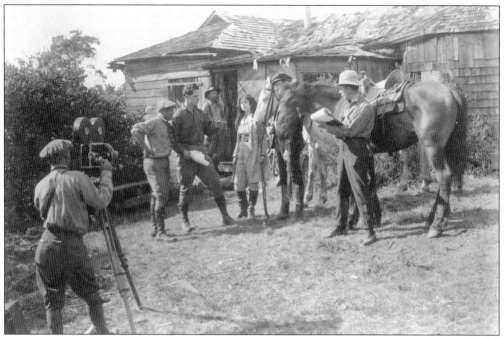

William Russell developed a solid fan following during the four years he was at the Flying A studio. He worked with some of the company's top directors, such as Henry King and Edward Sloman, but he also directed or codirected several of his films. Russell (holding script with hand raised) directs his wife, Charlotte Burton, and Harry Keenan in a scene for *The Strength of Donald McKenzie* (released August 3, 1916) while associate director Jack Prescott (right) looks on.

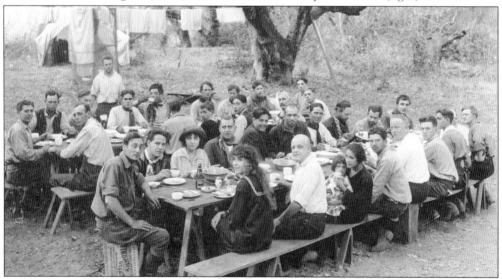

Lunch is served on location during production of *Snap Judgment* (released November 19, 1917). Director Edward Sloman is seated at the head of the table in the foreground. On the front bench are Francelia Billington (in sailor suit), Harvey Clark (next to Billington), cameraman Ira Morgan (fifth from left) and studio still and portrait photographer Gerald Carpenter (far right). In the back row of the front table, from left to right, are William Russell, Charlotte Burton, Clarence Burton, Ashton Dearholt, and Bull Montana.

Seven

AT THE EDGE OF THINGS

In 1916, the American Film Company was riding high. "We have doubled and then tripled our output," S. S. Hutchinson told *Picture-Play* reporter Robert C. Duncan, "and as we are adding pictures to our release list all the time, we have to keep building stages to allow all our directors to work at once."

Weekly payroll at the studio was $19,000 a week. Eighteen directors were working, 75 players were under contract, and as many as 500 day players and extras were regularly kept busy. There were 10 regular units—each with its own director, cinematographer, and stock company of actors—and several special units. The regular units were named Company Nos. 1, 2, and 3; Beauty Company Nos. 1 and 2; Mustang Company Nos. 1 and 2; the Clipper Company; the Humphreys Company; and the Feature Company. The other units were called Special Unit Nos. 1, 2, 3, and so on.

In addition to the studio property, American owned land that started about a mile and a half from the lot and stretched toward the foothills. "We own acres and acres of land around here," Hutchinson told Duncan, "and practically all of our exteriors, except those requiring special residential settings, are photographed on our territory."

Yet before the end of the year, operations were drastically slashed. Production commitments were pared back, and eight units were laid off at once, with several more to follow over the next year.

The war in Europe limited foreign sales, and at the same time, the domestic market for short films collapsed as audiences flocked to features. Low-end theaters that still adhered to the traditional shorts programs could be satisfied with reissues. But the bigger blow was the departure of Harry Aitken's Reliance-Majestic company and of Adam Kessel and Charles O. Baumann's New York Motion Picture Company, which deprived Mutual of several popular stars and directors and resulted in the formation of the rival Triangle Film Corporation. Mutual made up for the loss by signing Charlie Chaplin to a one-year contract, but it proved to be only a short-term solution.

Director Thomas Ricketts (1853–1939) rejoined American in Santa Barbara after Allan Dwan's departure in 1913. Ricketts continued to direct until 1919 and then became a character actor, playing frail and eccentric old men. Eccentricity may have come naturally. Although he is well turned out in the fashion of the day, a close examination shows that his high collar is quite frayed.

A scene from Ricketts's film *The Great Question* (released September 18, 1915) shows William Stowell (left), Harold Lockwood, and Eugenie Forde. Stowell (1885–1919) was killed in a train wreck while on location in the Belgian Congo. Eugenie Forde (1879–1940) was the mother of actress Victoria Forde, who later married cowboy star Tom Mix, and director Eugene J. Forde.

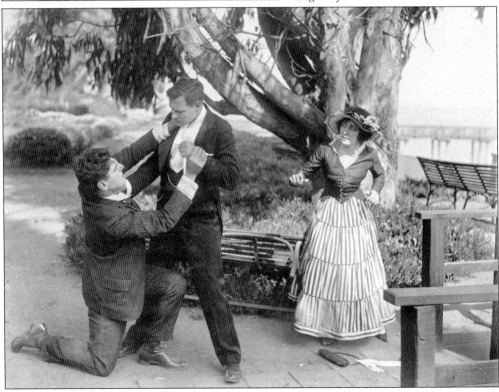

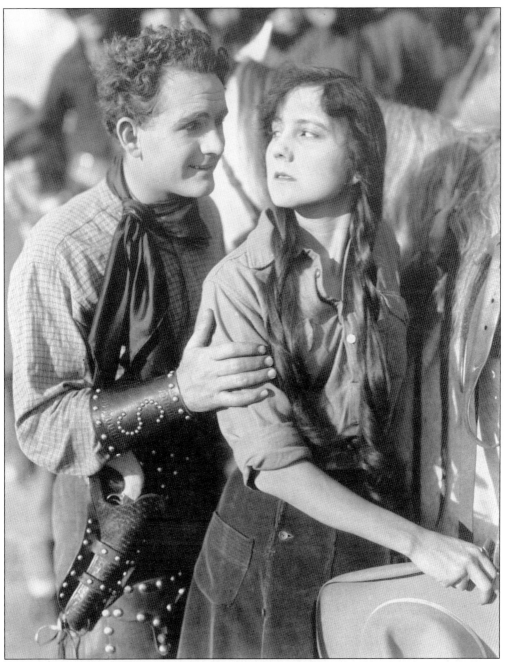

Among personnel let go in the studio's 1916 cutback were actor-director Frank Borzage and actress Anna Little. Both picked up their careers in Hollywood. Borzage won the first Best Director Oscar for *7th Heaven* (Fox, 1927), and a second gold statuette for his direction of *Bad Girl* (Fox, 1931). Anna Little (1891–1984) was born in California and raised on a ranch. She went on stage as a young girl and drifted into films in 1911. After leaving the Flying A, she shortened her first name to Ann and continued making pictures until 1925, quitting because she got tired of working, having been on stage and in pictures for nearly 20 years. She later managed the Chateau Marmont hotel in Hollywood and was also a Christian Science practitioner.

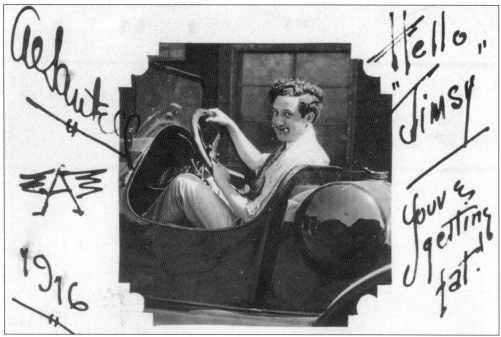

Al Santell (1895–1981) came to the Flying A in 1915 as a writer, but he also acted and directed his first picture, *Beloved Rogues* (released January 15, 1917), while at the studio. Laid off in the 1916 cutback, Santell went on to a long career as a filmmaker in Hollywood, directing such films as *The Patent Leather Kid* (First National, 1927), *Rebecca of Sunnybrook Farm* (Fox, 1932), and *Winterset* (RKO-Radio, 1936). His ungallant greeting of Jimsy Maye Eason refers to her pregnancy.

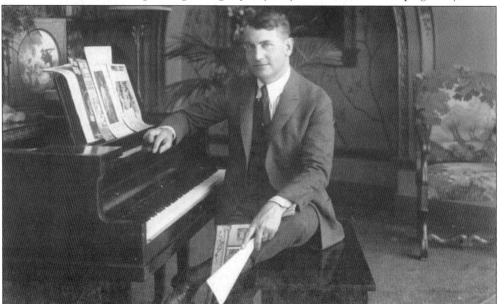

Unlike Al Santell, George L. Cox ended his screen career at the American Film Company. Cox began working in films at the Selig Polyscope Company in Chicago as an actor about 1912. He came to the Flying A in 1919 and directed all of the studio's final films. His screen credits ended in 1921 with the closing of the Santa Barbara studio.

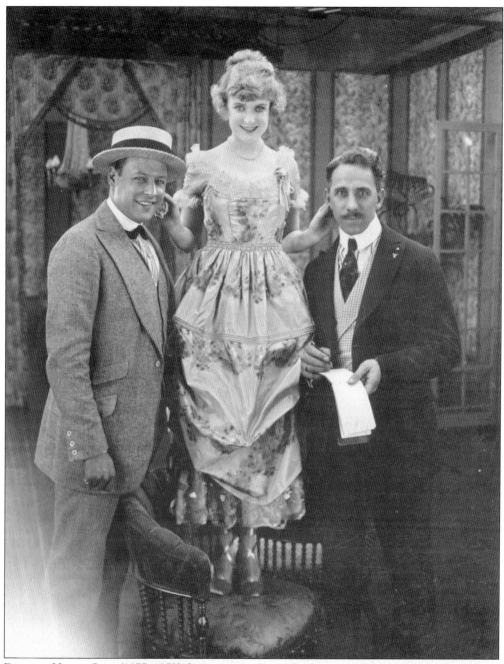

Director Henry Otto (1877–1952) first came to Santa Barbara in 1914 to work for the upstart Santa Barbara Motion Picture Company but soon signed with the Flying A, where he directed one- and two-reelers starring Edward Coxen and Winifred Greenwood. After leaving the studio, he would become closely associated with former Flying A stars Harold Lockwood (left) and May Allison at Metro Pictures. Otto's credits became spotty in the 1920s. Among his better-known later films were *The Temple of Venus* (Fox, 1923) and *Dante's Inferno* (Fox, 1924). He directed his last film in 1930 but appeared in bit parts in films into the early 1940s.

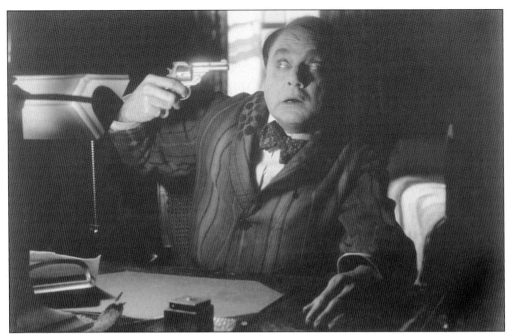

Actors who become directors sometimes turn their backs on the sort of commercial films that made them favorites with the public. The story of *Soulmates* (released May 8, 1916), directed by William Russell, was about Lowell Sherman (played by Russell), a man who discovers that his wife is having an affair with his best friend, Cyril Carr (played by Harry Keenan, above). Sherman ruins his friend in business, causing Carr to commit suicide, divorces his wife, and then finds his "soul mate" in Carr's widow.

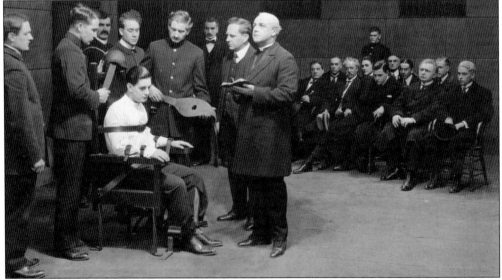

In *And the Law Says?* (released November 6, 1916), Lawrence Kirby (played by Richard Bennett, who also directed) gets his girlfriend pregnant and then skips town. Years later, Kirby has become a respected judge, and he unknowingly sentences his illegitimate son to death for a murder he did not commit. The son is executed, but in a sop to the audience, an attending doctor (played by George Periolat) revives the electrocuted corpse.

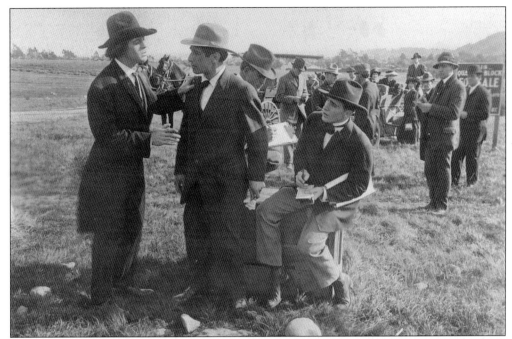

Also cast loose by the studio in 1916 was Ed Coxen. Most often teamed with Winifred Greenwood, Coxen appeared in more than 160 films during his nearly four years with the studio. *The Town of Nazareth* (released March 30, 1914) was a two-reeler written by Marc Edmund Jones about love and devotion through many years and based on the old saying, "Can anything good come out of Nazareth?" In the foreground from left to right are Ed Coxen, George Field, and B. Reeves Eason.

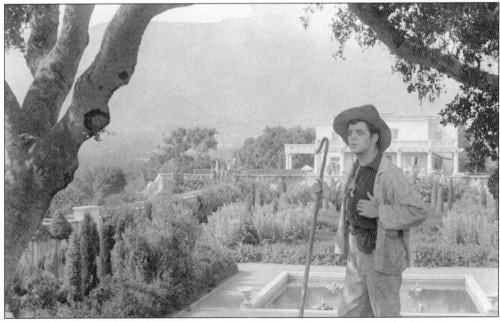

The Song of the Seashell (released August 28, 1914) was a one-reeler directed by Henry Otto. This scene was taken on the grounds of the Frederic Gould estate, off of San Leandro Lane in Montecito, just south of Santa Barbara.

Faxon M. Dean (1890–1965), described as being "as garrulous as the Venus de Milo" in a 1922 *American Cinematographer* profile, was Mary Miles Minter's favorite cameraman. He came to Hollywood after Minter left the Flying A. He continued working as a cinematographer until the early 1930s and then opened a camera-and-equipment rental business.

Pictured from left to right are Faxon Dean, director Carl M. LeViness, Vivian Rich, Alfred Vosburgh, assistant director Jack Halloway, and an unidentified coworker during production of *Pastures Green* (released July 24, 1916). In the film, a rich wastrel (Vosburgh) becomes engaged to a French dancer while drunk and hides out on his valet's farm to avoid the wedding. He falls for a milkmaid, but complications ensue when his fiancée is found dead and the police think he has taken flight to avoid prosecution.

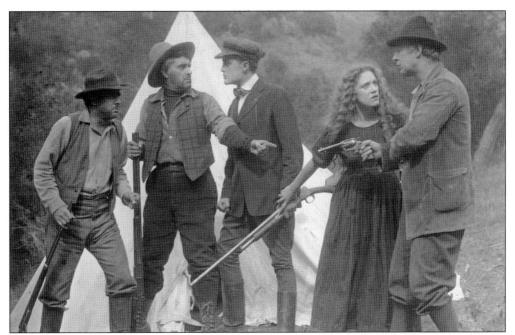

Helene Rosson (1897–1985), the sister of directors Richard and Arthur Rosson and cinematographer Hal Rosson, was briefly married to Flying A leading man Ashton Dearholt. She retired in 1925 after her second marriage. *April* (released April 10, 1916) was a five-reel Mutual Masterpicture starring Rosson.

Tom Chatterton (1881–1952) made only a handful of films in 1920 after leaving the Flying A in 1916. He preferred to work in live theater and only returned to movies in 1936, when he started turning up in "B" Westerns and serials. Rhea "Ginger" Mitchell (1890–1957) went on stage in 1909 and started working in pictures three years later. After leaving the Flying A, she continued working into the 1950s, often in bit parts or as an extra, and also managed an apartment building. Mitchell never married and was murdered by a disgruntled houseboy.

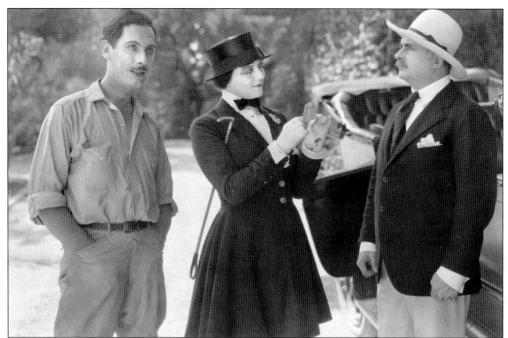

Although stars like William Russell, Mary Miles Minter, and Margarita Fisher were still under long-term contracts, the last star to be offered a multi-picture deal by the Flying A was Gail Kane (1887–1966), who made a half dozen movies for the studio in 1917. In *A Game of Wits* (released November 5, 1917), Kane played a young woman who agrees to marry her father's business rival (George Periolat, right) to settle a debt. When the debt is canceled, her boyfriend (Lew Cody, left) poses as an addlepated brother to scare the older man into believing insanity runs in her family.

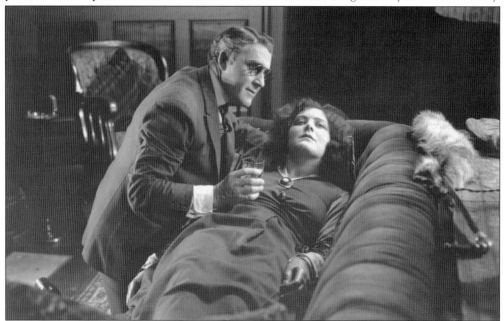

Gail Kane and Harry Von Meter are featured in *Whose Wife?* (released April 30, 1917), directed by Rollin Sturgeon.

Eight

THIRTY MINUTES OF MELODRAMA

The American Film Company was not Santa Barbara's only motion-picture studio. In June 1914, former Flying A executive Aubrey M. Kennedy joined forces with local dentist Elmer J. Boeseke to form the Santa Barbara Motion Picture Company, with studios at 1425 Chapala Street.

Just as the American Film Company raided Essanay to form its initial staff, the Santa Barbara Motion Picture Company raided the Flying A, taking director Lorimer Johnston, actress Carolyn Cooke, cameraman Roy Overbaugh, actor-director Scott Beal, and assistant cameraman Victor Fleming, among others.

The Santa Barbara Motion Picture Company was part of an ambitious attempt by Aubrey M. Kennedy to create a combine to rival the Mutual Film Corporation and Universal. He established Kriterion Film Service to act as distributor for the films and helped create a number of companies to supply product to Kriterion, including the Navajo Film Manufacturing Company, Alhambra Film Manufacturing Company, Crown City Film Company of Pasadena, and Kennedy Features.

The Santa Barbara Motion Picture Company's first film was *The Envoy Extraordinary*, an elaborate four-reel feature, but the company was soon turning out two-reelers. Although it advertised "The Powers That Be, Say: We Are Here to Stay," the Santa Barbara Motion Picture Company lasted only a few months and disappeared with the collapse of Kriterion Film Service in 1915.

As the rival Santa Barbara Motion Picture Company failed, S. S. Hutchinson expanded his production activities by creating two sister companies to turn out additional films for release through Mutual. The Signal Film Corporation was established in 1915 specifically to produce railroad serials and features starring Helen Holmes, who had appeared in Kalem's *Hazards of Helen* series. The signal studio was located in the Los Angeles suburb of Highland Park near the tracks of the Los Angeles and Salt Lake Railroad. Starting in 1916, the Vogue Film Company produced two-reel comedies at studios on Gower Street at Santa Monica Boulevard in Hollywood. Vogue comedies featured such stars as Ben Turpin, Paddy McQuire, and Rube Miller. Both of these Flying A satellite companies ceased operations in 1917 as the fortunes of the Mutual Film Corporation declined.

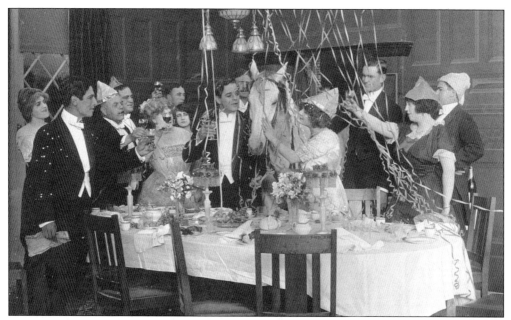

Pictured at the table are, from left to right, George Field, John Steppling, Ida Lewis, Ed Coxen, Blue Knot, Winifred Greenwood, Elmer Boeseke, and Eugenie Forde in the Flying A one-reeler *Blue Knot, King of Polo* (released June 24, 1914). Boeseke, a leader in Santa Barbara society, had a string of polo ponies, which included Blue Knot. This was Boeseke's introduction to the movie business, but he soon partnered with former Flying A executive Aubrey M. Kennedy to form the Santa Barbara Motion Picture Company.

This advertisement for the Santa Barbara Motion Picture Company appeared in the program for the February 13, 1915, Photoplayers Club Ball.

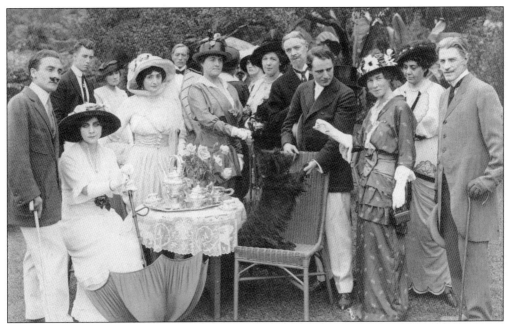

Some stockholders and players of the Santa Barbara Motion Picture Company posed for this shot, including actor-director Scott Beal (far left) and his wife, Carolyn Cooke (wearing white hat), Mrs. John Beal (later Mrs. J. H. Child, in gray behind roses), Jack Nelson (holding chair), and Mabel Cunnane (with gloved hand raised).

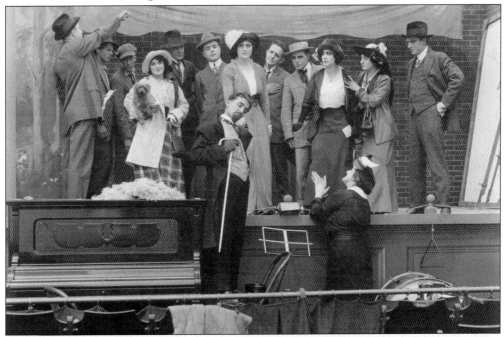

A scene from the Santa Barbara Motion Picture Company production *Thirty Minutes of Melodrama* (released October 1914) poked fun at the "popular priced" live theater. Louise Lester applauds in the orchestra pit, and Scott Beal (Lester's son off screen) holds the white cane. Carolyn Cooke and Jack Nelson are at the right of the stage.

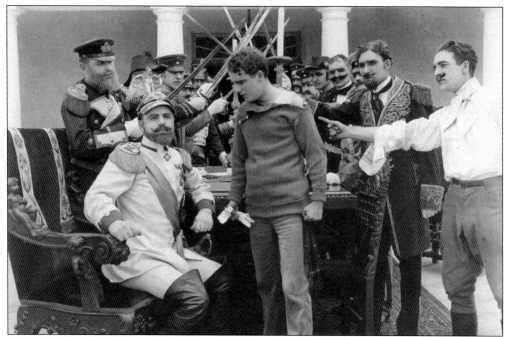

The Envoy Extraordinary (1914) was directed by Lorimer Johnston and photographed by Roy Overbaugh. Surviving stills suggest that the Santa Barbara Motion Picture Company films lacked production polish compared with the Flying A product. Jack Nelson (center) reports to the emperor. Scott Beal is at right.

The enemy makes blindfolded Jack Nelson walk the plank in *The Envoy Extraordinary*. The mustachioed bit player standing at right is Victor Fleming, who came to the Flying A as an automobile mechanic and chauffeur in 1912. He eventually directed the classics *The Wizard of Oz* and *Gone With the Wind* (both 1939).

The Birth of Emotion (released January 1915) was produced by the Santa Barbara Motion Picture Company, although it was released under the Alhambra Film Company brand through MICA (Made in California) Film Service. Directed by Henry Otto and photographed by Roy Overbaugh, the film told a story of passion and murder with a flashback to caveman days to illustrate how man's baser emotions developed. Marty Martin as a leaf-clad primitive girl sees her lover strangled by a rival suitor.

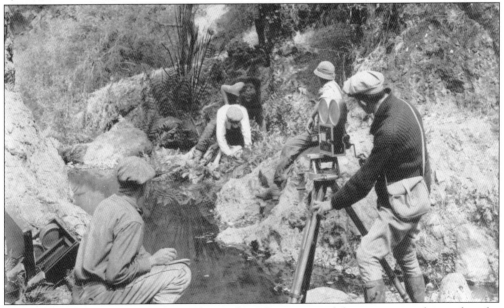

Cameraman Roy Overbaugh shoots the modern-day version of the same scene depicted in the top still from *The Birth of Emotion*. Onscreen the action dissolved from the present to the past as the story unfolded.

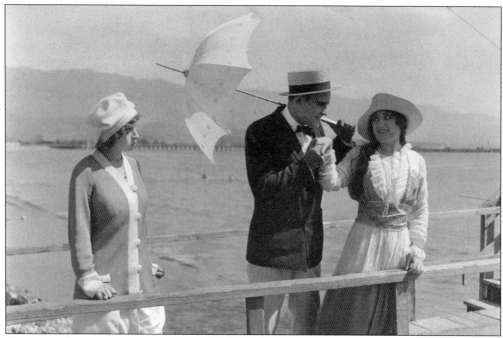

This scene from an unidentified Santa Barbara film depicts, from left to right, Marty Martin, Page Peters (1889–1916), and Reina Valdez. Valdez had appeared in films for Lubin, Essanay, and Flying A before signing with the Santa Barbara Motion Picture Company. Page Peters worked at Universal and the California Motion Picture Company before coming to Santa Barbara. He died at age 27 in a drowning accident at Hermosa Beach, California.

The Santa Barbara Mission was a setting for *The Keeper of the Flock* (1915). The film featured Reina Valdez and Louis Bennison. Although he played a Catholic priest, Bennison had a stormy private life. He committed suicide in New York on June 6, 1929, after murdering actress Margaret Lawrence.

S. S. Hutchinson established the Signal Film Corporation in 1915 as a satellite operation to the American Film Company to produce railroad films with Helen Holmes and J. P. McGowan. By the time Helen Holmes (1893–1950) signed with Signal, she was well-known as the original star of the Kalem Company's long-running *Hazards of Helen* series. She was married to her director and costar, J. P. McGowan (1880–1952), but they divorced in 1925. This trade advertisement for the first Signal Film Corporation production, *The Girl and the Game*, shows Holmes and McGowan in a tense moment and promises exhibitors 15 weeks of steady profits.

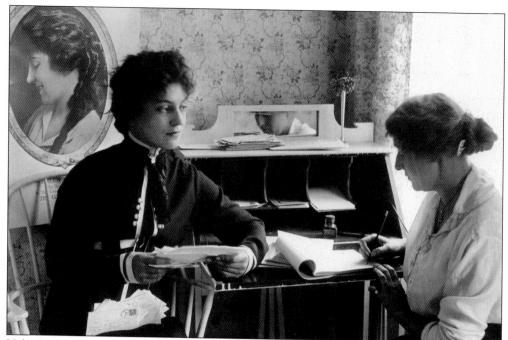

Helen Holmes sits in her dressing room at the Signal Studio dictating answers to her fan mail. Even in the 1910s, it would have been rare for a fan to receive a personal reply from one of their screen favorites. It was more common for studios to send out printed responses suggesting that the fan purchase 5-by-7-inch or 8-by-10-inch photographs at 10¢ and 25¢ apiece.

As her crew members subdue some attackers in the background, Helen Holmes reads a warning note and tells her foreman, "We must stop the log train!" in chapter three of the Signal Film Company serial *A Lass of the Lumberlands* (1916).

The Railroad Raiders (1917) was the last Holmes-McGowan Signal Film Corporation serial. The Signal Studio was located along the tracks of the Salt Lake and Los Angeles Railroad, and a nearby spur line made it possible to shoot stunts without disrupting scheduled runs. This is a scene from chapter 14, "The Trap."

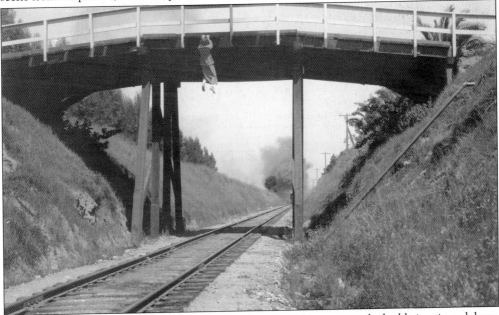

In an earlier episode of *The Railroad Raiders*, Helen, or in this case a male double in wig and dress, attempts to board a runaway train.

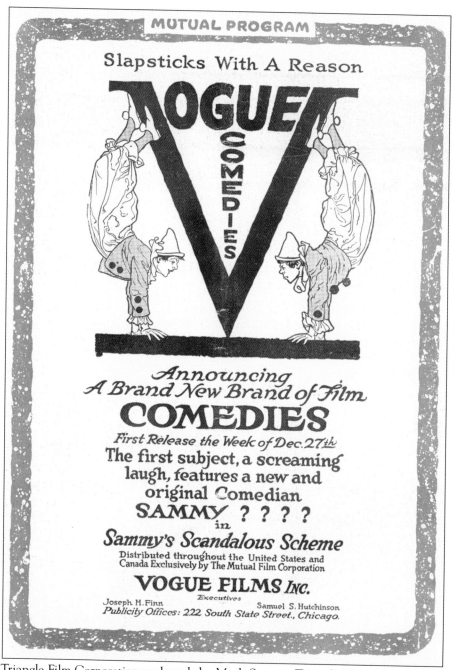

The Triangle Film Corporation packaged the Mack Sennett Triangle-Keystone comedies with features produced by Ince-Triangle-KayBee and D. W. Griffith's Fine Arts Pictures to provide exhibitors a "balanced program." Mutual followed suit by signing Charlie Chaplin, arguably the most popular film star of the day, to a one-year contract. But Chaplin was only slated to turn out a dozen pictures over the course of a year. To fill out Mutual's comedy schedule, S. S. Hutchinson established the Vogue Film Company as another Flying A satellite. The leading Vogue stars were Ben Turpin and Paddy McQuire, who had both worked with Chaplin at Essanay, and Rube Miller, one of Sennett's original Keystone Kops.

Seen here is the Vogue studio, located at Santa Monica Boulevard and Gower Street in Hollywood, probably during production of *The Delinquent Bride Groom* (released June 1916). Seated on the floor up front are, from left to right, director John Francis Dillon, Lillian Hamilton, Ben Turpin, and Paddy McQuire.

Ben Turpin is featured in *A Studio Stampede* (released March 1917). Turpin (1869–1940), with his distinctive crossed eyes, began his film career at the Essanay Film Manufacturing Company in Chicago in 1907. He appeared in more than 30 two-reelers for Vogue, and the emphasis was clearly on quantity rather than quality.

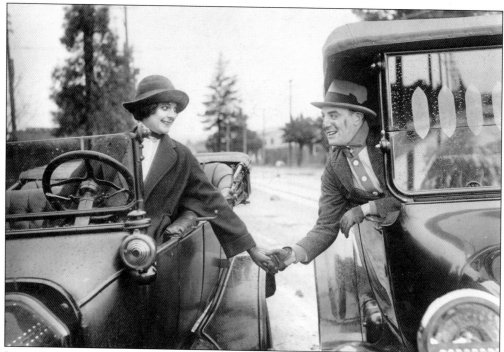

Love, Dynamite and Baseball (released March 1916) was one of the "polite" comedies Vogue produced featuring Priscilla Dean and Jack Dillon. Dean (1896–1987) began her film career in 1911 as a comic ingenue, and she became one of Universal's top stars in the early 1920s. Dillon (1884–1934) started appearing in comedies for Nestor-Universal in 1914 and soon began directing. He would become a top Hollywood director with credits like *Kismet* (Warner Brothers, 1930) and *Call Her Savage* (Fox, 1932).

This scene is from *The Plaster Feud* (1917), one of the last Vogue comedies. By the time this film was made, most of the name talent on the Vogue roster had moved to other studios.

Nine

ALL THE WORLD TO NOTHING

In 1918, the Mutual Film Corporation collapsed, leaving the American Film Company without a distributor. S. S. Hutchinson arranged with Pathé Exchange, Inc., to take over the physical distribution of the studio's releases and set up separate American Film Company sales desks within the Pathé branches.

The company had three units producing features starring William Russell, Mary Miles Minter, and Margarita Fisher. The production schedule remained robust with 28 films on the slate, but Minter was lured away in late 1918 by Realart Pictures, a subsidiary of Paramount Pictures, and William Russell would leave in 1919 to sign with the Fox Film Corporation.

American made only 16 features in 1919. *Six Feet Four*, which was released in September, starred William Russell, and was directed by Henry King, would be the studio's last unqualified success. Henry King paid $1,500 for the screen rights to Jackson Gregory's novel, and the studio only reluctantly agreed to produce the film and reimburse King for his out-of-pocket expenditure. At six reels, *Six Feet Four* was a full reel longer than the standard Flying A feature, but, according to King, it was so successful that it made back its production costs in New York and was already in profit as it played the rest of the country.

Hutchinson decided to make only bigger six-reel pictures, but only Margarita Fisher remained under contract. The rest of the films were filled out with stars borrowed from other studios or signed for one picture at a time.

American turned out only 10 new pictures in 1920 and began to retitle and reissue the last Mutual releases, which had received short shrift in the marketplace. Of the unlucky 13 pictures released by American in 1921, two were new productions. The rest were reissues. The last new production released was appropriately titled *Payment Guaranteed*.

The economic recession of 1921 hit the picture business hard, and while the Flying A announced plans to resume production, it never did.

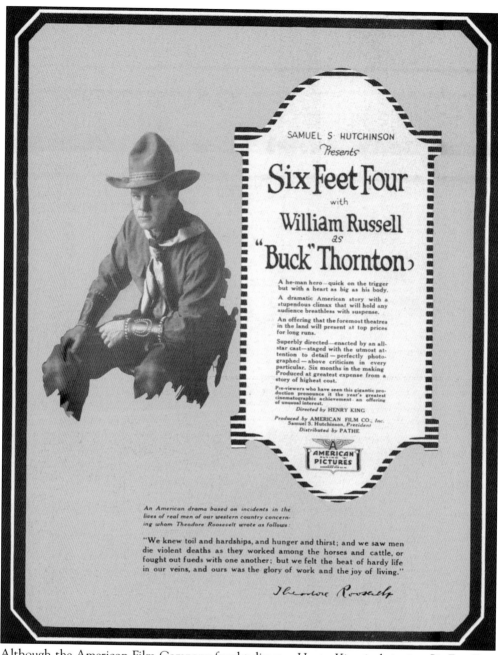

An American drama based on incidents in the lives of real men of our western country concerning whom Theodore Roosevelt wrote as follows:

"We knew toil and hardships, and hunger and thirst; and we saw men die violent deaths as they worked among the horses and cattle, or fought out feuds with one another; but we felt the beat of hardy life in our veins, and ours was the glory of work and the joy of living."

Theodore Roosevelt

Although the American Film Company fought director Henry King in bringing *Six Feet Four* (released September 1, 1919) to the screen, by the time it was ready for release, the studio boasted that it was "superbly directed . . . above criticism in every particular . . . [and] Produced at greatest expense from a story of highest cost." The studio embarked on a policy of "big pictures only," but both William Russell and director Henry King were lured away by Hollywood, and Mary Miles Minter also left the Flying A. The company promoted Margarita Fisher as their top star and brought in freelance actors and directors to make additional pictures. However, without a steady flow of regular releases, studio overhead made film budgets soar, and a 1921 economic downturn put the final nail in the company's coffin.

Rupert Julian (hand raised) was brought from Hollywood to direct *The Honey Bee* (released April 1, 1920), which featured a boxing match between Nigel Barrie (center) and Norman "Kid McCoy" Selby (right). Julian (1879–1943) is best remembered for directing *The Phantom of the Opera* (Universal, 1925). Selby (1873–1940) won the middleweight boxing championship in 1897 and appeared in over a dozen films between 1916 and 1923. Married as many as 11 times, he was convicted of manslaughter in the death of Theresa Mors in 1924 and sentenced to 10 years in prison.

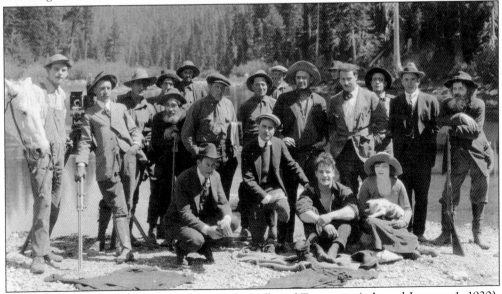

The cast and crew were on location for *The Valley of Tomorrow* (released January 1, 1920). Included are Louis King (brother of Henry King, left), cinematographer Georges Rizard (leaning on camera), and (seated from left to right) director Emmett J. Flynn, William Russell, and leading lady Mary Thurman.

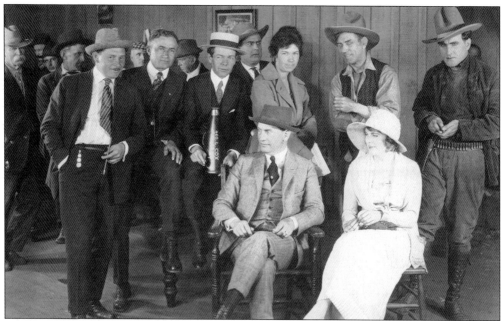

On the set of *Sunset Jones* (released March 1, 1921) are, standing from left to right, assistant director Sidney Algier, photographic department head Alois G. Heimerl, Jack Brammall (holding George L. Cox's megaphone), editor and continuity clerk Grace Meston, unidentified, and Al Ferguson. Seated in front are director George L. Cox and actress Kathleen O'Connor.

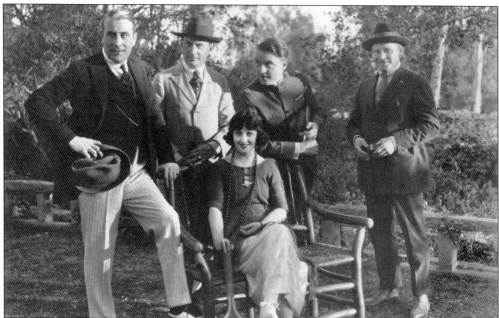

Seen during production of *The Thirtieth Piece of Silver* (released May 1, 1920) are Margarita Fisher (seated center) and (standing from left to right) King Baggot, director George L. Cox, Forrest Stanley, and assistant director Sidney Algier. Baggot (1879–1948) was one of the first actors to receive star billing in films. He began his screen career in 1909 with IMP. Baggot spent most of his early career in the East, and this Flying A production was one of his first assignments on the West Coast.

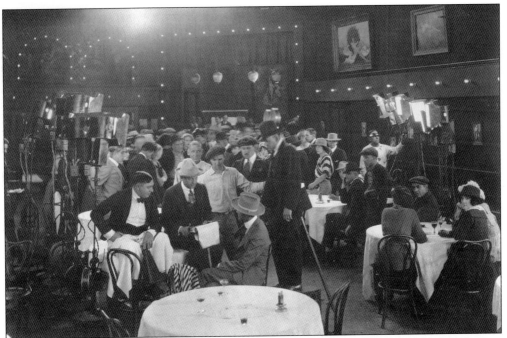

Seated at the table on the set of *The Hellion* (released September 1, 1919) are assistant director Sidney Algier (doubling as a waiter) and director George L. Cox.

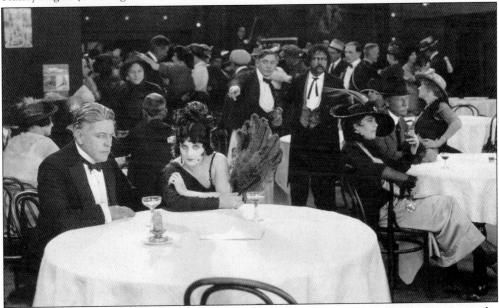

In *The Hellion*, Joseph Harper squanders his niece's inheritance, and she goes insane over the loss of her fortune and the presumed death of her lover in the war. The lover, however, is alive and has a fortune of his own that Harper hopes to control. In this scene, Joseph Harper (played by Henry A. Barrows, left) tries to convince cabaret performer Mazie Del Mar (Margarita Fisher) to take the place of his niece, whom Del Mar resembles. Del Mar's boss, Signor Enrico (George Periolat, with mustache and string tie), controls Mazie with hypnotism. Waiter Sidney Algier points Enrico to the table.

1922 ©A.F.Co.

On October 11, 1919, Albert I, King of the Belgians (1875–1934), arrived in Santa Barbara as part of a goodwill tour designed to thank America for its aid to Belgium during the Great War. Born Albert Léopold Clément Marie Meinrad in Brussels, he was the younger son of Philip, Count of Flanders, and succeeded his uncle, Leopold II of Belgium, on the Belgian throne in 1909. On his first day in town, a Flying A cameraman shot footage of the king going up in the air on a Loughhead seaplane. When he visited the studio two days later, on Monday morning, October 13, the king watched a movie being made and saw footage of his Saturday flight in the studio projection room.

124

"Up before five, breakfast on top of the mountain, motor rides, audiences, tree planting, receptions, a trip to a motion picture studio, a polo game, a horseback ride—these made King Albert's last day in Santa Barbara full of activity," according to the *Santa Barbara Morning Press*. The king's arrival drew only a few onlookers.

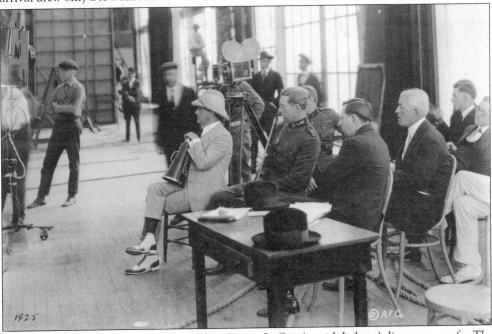

On the big glass stage, King Albert watches George L. Cox (in pith helmet) direct a scene for *The Week-End* (released August 1, 1920), which starred Margarita Fisher. Behind the king is Santa Barbara police chief Desgrandchamp. Seated with arms folded and back to the camera is J. M. Nye, chief of special agents, speaking with Santa Barbara city manager Robert Craig.

In 1920, the American Film Company closed its gates, intending to release its backlog of unreleased films and reissue the late Mutual releases that had not had many bookings. It was announced that the closing would be temporary, but the Flying A never produced another film. The American Film Company laboratories in Chicago remained active for a number of years after the studio closed, processing film for other producers, and S. S. Hutchinson occasionally leased the Flying A studios to other filmmakers.

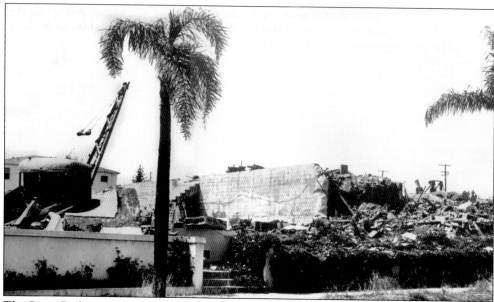

The Santa Barbara studio served as a National Guard armory for a time, and community dances were occasionally held on the big glass stage. Most of the studio was finally torn down in 1948.

The dressing rooms and studio commissary were not torn down. From the street, the commissary building is unrecognizable today, but the row of dressing rooms looks very much as it did when the Flying A studio opened in 1913. For many years, Mrs. E. W. Adams and her son Arleigh lived in the dressing rooms and operated a chair-caning business in the former studio green room. Today the block of dressing rooms serves as the offices of architect Peter Becker.

ACROSS AMERICA, PEOPLE ARE DISCOVERING SOMETHING WONDERFUL. *THEIR HERITAGE.*

Arcadia Publishing is the leading local history publisher in the United States. With more than 3,000 titles in print and hundreds of new titles released every year, Arcadia has extensive specialized experience chronicling the history of communities and celebrating America's hidden stories, bringing to life the people, places, and events from the past. To discover the history of other communities across the nation, please visit:

www.arcadiapublishing.com

Customized search tools allow you to find regional history books about the town where you grew up, the cities where your friends and family live, the town where your parents met, or even that retirement spot you've been dreaming about.